Looking at Pictures

Looking at Pictures

An Introduction to Art for Young People

JOY RICHARDSON
With illustrations by Charlotte Voake

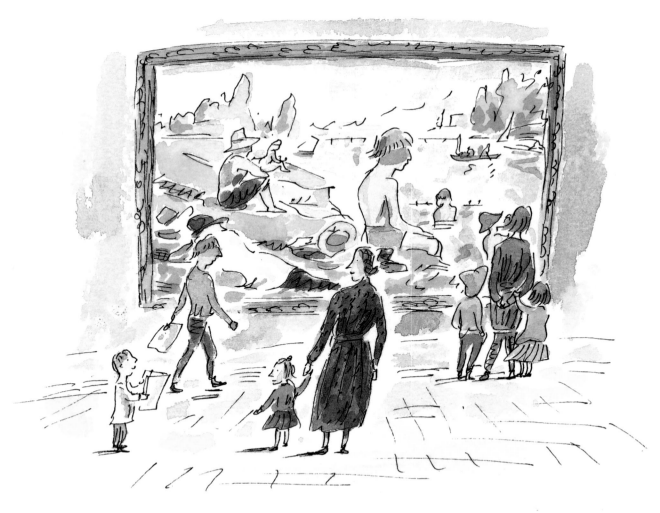

Revised Edition
Published in Association with The National Gallery, London
Abrams Books for Young Readers, New York

Created by National Gallery Company Limited, London

Library of Congress Cataloging-in-Publication Data
Richardson, Joy.
 Looking at pictures : an introduction to art for young people
/ by Joy Richardson ; with illustrations by Charlotte Voake. —
Rev. ed.
 p. cm.
 Includes bibliographical references and index.
 ISBN 978-0-8109-8288-8 (harry n. abrams, inc. : alk. paper)
 1. Painting—Appreciation—Juvenile literature. 2. National
Gallery (Great Britain)—Juvenile literature. I. Voake,
Charlotte. II. Title.

 ND1146.R5 2009
 750.1'1—dc22
 2008055684

Project editor: Jan Green
Educational consultant: Rosemary Davidson
Designer: Heather Bowen, from an original concept
 by Gillian Greenwood

Front cover and detail, p. 2:
Georges-Pierre Seurat, *Bathers at Asnières*

Dimensions of paintings are given to the
nearest whole number.

Digital reprographics by DL Interactive UK
Printed and bound in Hong Kong by Printing Express
10 9 8 7 6 5 4 3 2 1

Abrams Books for Young Readers are available at special
discounts when purchased in quantity for premiums and
promotions as well as fundraising or educational use. Special
editions can also be created to specification. For details, contact
specialmarkets@hnabooks.com or the address below.

HNA
harry n. abrams, inc.
a subsidiary of La Martinière Groupe

115 West 18th Street
New York, NY 10011
www.hnabooks.com

Contents

Director's preface

All the paintings in this book are in the National Gallery, in Trafalgar Square in London, and anyone can come and look at them for free. All of us have, at some time in our lives, made drawings or paintings, and we still enjoy looking at pictures even if we're not always quite sure what they are pictures of. Sometimes it's obvious – but very often we've forgotten, or never knew, the stories in them, or why people made them in the first place, or even who they were painted by. Most of these pictures were never meant to be seen in galleries, but were made for churches, grand palaces, or smaller, more private spaces in people's homes. Others, especially the very oldest ones, have pieces missing, or the colours appear different from when they were originally painted, and some of them seem, frankly, quite odd. There are many reasons why a picture painted in France in the nineteenth century, for example, looks different from another, painted in Italy in the fifteenth. So we expect you to wonder about them, and to ask questions about them, and hope that this book contains some of the answers.

Looking at Pictures shows you just a few of the National Gallery's paintings. If you live near enough to visit, you can see many more, but even if not, there is probably a collection near you where you can see similar pictures. I hope that Looking at Pictures will inspire you to find out more about our paintings – they are yours too – and encourage you to look at and enjoy others.

Nicholas Penny
Director, The National Gallery

6

About this book

In this book you will find reproductions of paintings produced over more than 700 years – from the thirteenth century to the twentieth – for different purposes, places and people. These paintings come from all over Europe, and there are paintings like them in galleries all over the world, and perhaps near where you live.

When you go to an art gallery, don't expect to see everything in one visit. You may want to look at just one picture, or a few that especially interest you. Galleries can be busy and crowded places; with this book, you can quietly enjoy the pictures at home, in your own time. If you like making your own paintings, *Looking at Pictures* also tells you something about how artists of the past made theirs.

Of course, looking at reproductions is not the same as looking at the paintings themselves; you don't get much idea of size from pictures in a book, and colours and textures never look quite like the real thing. But you can dip into a book whenever you want, and you can pick and choose – you don't have to read it from cover to cover.

The first few pages, *Introducing paintings* and *Behind the scenes*, answer such questions as how the paintings come to be in the gallery, or why they have frames, and also tell you something about how scientists and restorers study and care for the paintings. But you can turn straight to the pages which describe the pictures. There are 12 chapters, beginning with *Painting for a purpose* on page 16. The list of contents on page 5 tells you what each chapter is about and will help you to find the subjects that particularly interest you.

Looking at Pictures will not tell you everything there is to know about paintings, but we hope that reading this book will tell you about the ones you like, and encourage you to look again.

INTRODUCING PAINTINGS

What are paintings for?

Most of the pictures reproduced in this book were not meant to be hung in an art gallery. So why were they made in the first place?

Many of the paintings in the National Gallery, especially the oldest ones, were made for Christian churches. They were meant to help people concentrate on their prayers, or to remind them of the holy stories. Other pictures were painted for the walls of palaces or other grand public buildings, as decoration, or to show how important the owners were. The subjects of these pictures were not always religious. They might illustrate famous stories from history, or from ancient myths.

But people also wanted more personal pictures – smaller religious ones, perhaps, to keep at home for private prayers or to carry around with them on their travels. Portraits were popular too, although many centuries later we may not know the identity of the people in them. And from the seventeenth century onwards, there were more and more paintings of the familiar things of everyday life.

Many pictures were made to order, or commissioned, but this was not true of all pictures. Some were produced by artists who painted popular subjects or tried out new ideas, hoping to find a buyer later.

What is an art gallery?

Most art galleries and museums began life as collections, sometimes made by just one person. Not because they wanted to build a museum but because they were fascinated by collecting – whether paintings, photographs, pottery, toys or clothes. Collections are interesting for all sorts of reasons. They tell us about the people who put them together, and the sort of world in which they lived. Nowadays there are museums and galleries devoted to anything and everything, including furniture, dinosaurs and space exploration.

Paintings for everyone

The idea of galleries and museums that anyone can visit is quite a modern one. Until about 200 years ago, great works of art were nearly all in churches and palaces, or belonged to wealthy collectors who would show them to their friends.

By the early nineteenth century, some European countries, such as France and Germany, already had great public art galleries. In Britain, there was a growing feeling that everyone, not just artists and educated people, should be able to enjoy great paintings. And that it was good for them, and for society as a whole, that they should do so. Since the National Gallery was first opened in London in 1824 with just 38 paintings, the pictures have belonged to the British people, and everyone can come to look at them. About 4¾ million people, many of them from abroad, visit the National Gallery each year. In the United States, the Metropolitan Museum of Art in New York was founded in 1870 and about 5 million visit it each year.

The National Gallery now has over 2000 paintings, quite a small collection compared to some other famous ones. Some were gifts and some were bought by the Gallery, which has tried to collect the best examples of European painting across the centuries. The earliest picture in the Gallery dates from about 1260 and the most recent about 1900. Twentieth-century painting and sculpture is held in other galleries.

Some galleries, including the National Gallery, offer visitors all sorts of things to do as well as looking at the paintings. Sometimes people just want to get out of the rain, have lunch, or meet friends. There may be film shows, lectures, computer rooms and shops to visit. The choice is yours.

POSTCARDS

ENJOYING
THE
GALLERY

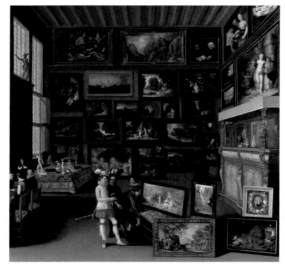

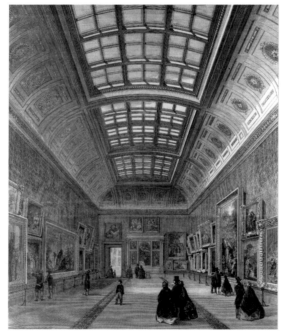

Arranging paintings

If you have ever made your own collection of anything, you will probably have thought about how to arrange it. Do the objects look best on their own, or together on a shelf? Can you organise them in groups, by size, shape or colour? Art galleries have the same problem. Should paintings be displayed one at a time, or hung on the wall together for comparison? Do they look best in a row around the room, stacked above each other, or tucked away in alcoves?

When the National Gallery first opened, with just a few rooms, pictures were soon packed tight from floor to ceiling. In 1845 the Keeper of the Gallery protested. 'It is not desirable to cover every blank space at any height, merely for the sake of clothing the walls.' He wanted to arrange the paintings in historical order, and make them easier to see.

Nowadays paintings are hung in different parts of the Gallery according to the date they were painted. Small paintings are usually put in small rooms, almost as if they were in someone's house. Large pictures which once belonged in great buildings look better in spacious rooms where you can see them clearly as you approach.

The way you see a painting is affected by how high it is hung, how the light falls on it, the colour of the wall behind it and the paintings around it.

(Top) This Flemish picture of around 1620 shows *cognoscenti* (an Italian word meaning art lovers) looking at a collection of pictures.

(Above) This photograph of a room in the National Gallery in the 1860s shows just how crowded the walls were at one time.

(Left) This painting by Cima was made for a church and the way the National Gallery displays it reminds us of this.

BEHIND THE SCENES IN A GALLERY

In the frame

As in most galleries, every painting has a frame and this helps to protect the picture. When the painting is hung on a wall, the frame marks it out from its surroundings, drawing your eyes into the picture as if through a window.

Some pictures have other pictures in them, such as this painting (left), by Gabriel Metsu. Fashions in frames change, and paintings like this provide wonderful clues. The plain black frame you see here, and the decorated gold one, were both popular styles in seventeenth-century Holland, when Metsu painted this.

Since about 1400, most frames have been made separately from paintings and not many pictures keep the same frame all their life. In the Gallery, experts fit paintings with frames which suit the size, style and age of the picture. They buy and repair old frames as well as making new ones to old patterns. The photograph below shows a rare and valuable frame made in Italy in the sixteenth century.

A man and a woman seated by a virginal by Gabriel Metsu

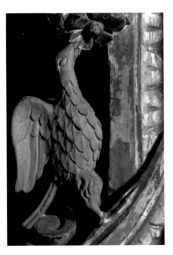

(Far right) Restoring a sixteenth-century Venetian frame in the National Gallery framing department.

(Right) Detail of the bird. One of the carved birds had been lost, so framers carved a new one to match.

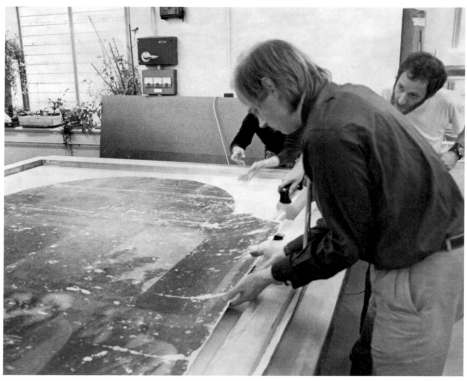

Restorers working on Cima's painting *The incredulity of Saint Thomas.*

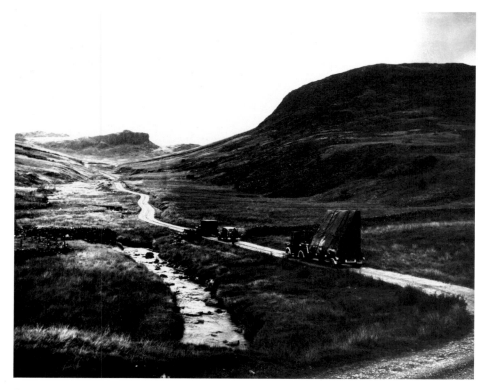

Paintings were taken by truck up into the mountains in Wales, to protect them from the bombing of London during the second world war.

Amazing survivals

Many paintings are hundreds of years old, and they didn't always look just as they do now. For example, years ago, large altarpieces, which were made in several sections, were sometimes taken down from where they originally belonged and divided up. Some of the pieces may have been lost or damaged and we are left with only part of the whole. It's like a jigsaw with some of the bits missing – we have to work out how it once looked. Sometimes, missing pieces have ended up in the collections of other galleries around the world.

Some old paintings have stayed in the same family for centuries, but most have changed hands many times before coming into an art gallery. Other pictures have an extraordinary life story and have survived despite being lost, stolen, forgotten or damaged.

Running repairs

The painting (right) by Cima was made for an altar in a church. Centuries later it suffered a terrible soaking when a canal overflowed in Venice and flooded the room in which it was being stored. When it came to the Gallery many years afterwards it needed very complicated repairing. The wood panel it was painted on was too weak to support the blistering, flaking paint. Restorers carefully cut away the wood from the back of the painting. They then attached the paint layers to a fibreglass panel and set about restoring the paint surface. Now it hangs safely in the Gallery.

Good housekeeping

In the nineteenth century, London's dirty air made the paintings very grimy. People even thought the Gallery might have to move out of the centre of London. In the end it stayed where it was so that working people could visit it easily. Nowadays the air in the Gallery is filtered and balanced, so that it is not too dry or too damp, and the temperature is controlled. This all helps to preserve the paintings.

During the second world war, the paintings in the National Gallery were in danger from bombs. They were all taken away to Wales in a convoy of trucks and stored underground in a slate mine, specially adapted to provide the right environment for paintings. But people missed them so much that one painting at a time was brought back and put on show, as the 'painting of the month', to help keep spirits up while the war lasted.

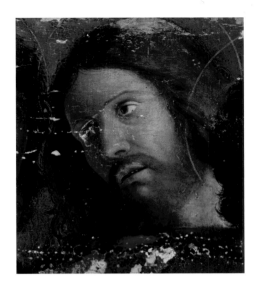

The head of an apostle, during restoration. This painting had been very badly damaged, and quite large areas of paint had been lost.

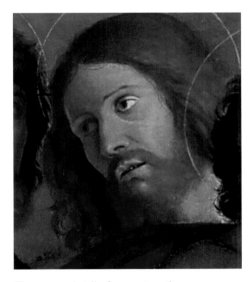

The same detail after restoration.

The incredulity of Saint Thomas by Giovanni Battista Cima

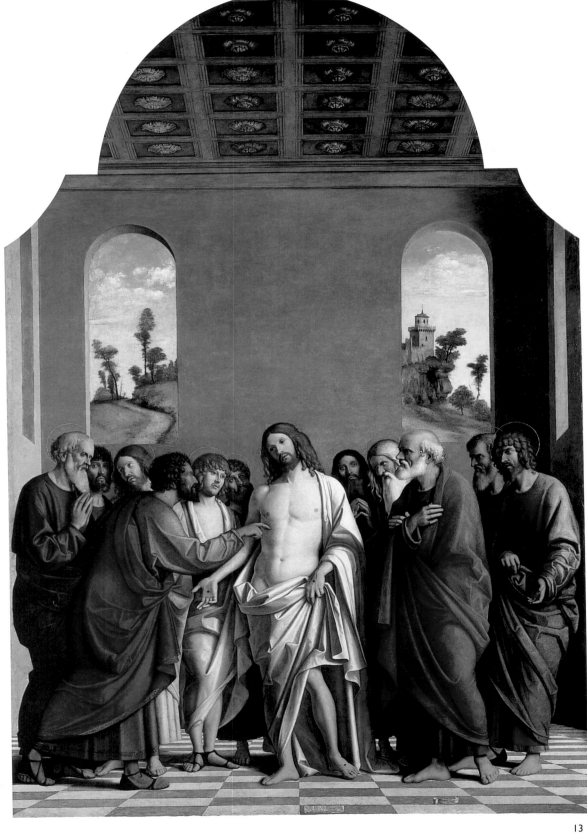

Detective work

Beneath the surface

Paintings are not just painted surfaces, but complicated objects made up of different layers and materials. (There's more about this on page 32.) Examining paintings with the naked eye provides a lot of information about how they were made, but restorers and scientists also have technology to help them.

X-rays

Restorers often use X-rays to examine pictures, just as doctors use them to examine their patients. Some paint contains lead, which doesn't allow X-rays to pass through. So areas with that paint on them show up white on the X-ray image. It's rather like looking at the skeleton of a painting.

Artists often change their minds while working on a picture. Francisco de Goya painted this portrait of Doña Isabel de Porcel (left). X-rays revealed a hidden portrait of a man looking in the opposite direction. He had not been seen since Goya decided to re-use the canvas for another painting.

Infrared photography

In some paintings, infrared photography can show up drawings under the paint layers (but only if the drawing was done with something made of carbon, such as charcoal). In this detail below of the painting by Jan van Eyck, the artist first *drew* the man's hand in one position, but changed it by the time he came to *paint* it. You can see the whole picture on page 27.

Doña Isabel de Porcel by Goya (above), and (below), an X-ray detail of the same painting showing a man's portrait underneath.

A detail of the man's raised hand from *The Arnolfini portrait* using an infrared camera which shows the drawing under the painting.

The same detail using ordinary photography which shows the surface of the painting as we see it.

Microscopes

Powerful microscopes can be used for looking at the surface of pictures. Even quite a low level of magnification can tell us about how the painting was made, and identify any damage or repainted areas.

Tiny specks of paint can be removed from the edge of a damaged part of a painting and looked at under the microscope at high magnification. This shows all the different layers of paint used in that part of the painting, rather like looking sideways at a sandwich. Scientists can then identify the ingredients used to make each paint layer.

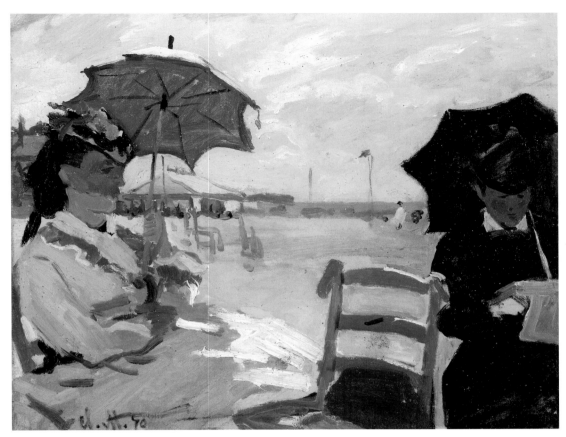

The beach at Trouville by Claude Monet

Enlarged detail of *The beach at Trouville.*
You can see tiny fragments of shell and sand from the beach, which became mixed with the paint as Monet worked.

A cross-section through a tiny sample of paint, magnified × 180, from Titian's *Bacchus and Ariadne,* on page 39.

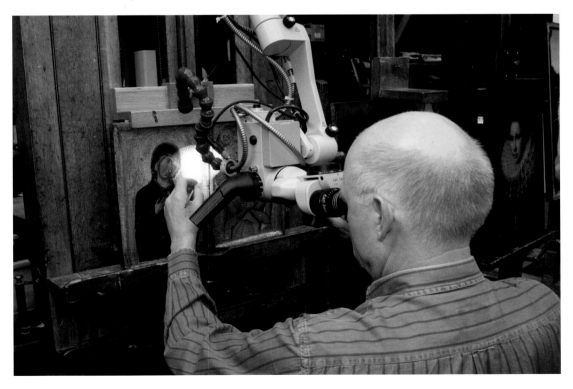

(Right) Scientists use powerful microscopes to examine paintings.

The artist has shown several musical instruments but we don't know if they would all have been played together.

PAINTING FOR A PURPOSE

The Coronation of the Virgin
probably by **Jacopo di Cione**

In the fourteenth century, most European paintings were made for Christian churches.

Noble families and churchmen often had their family chapels and altars, where the priest celebrated the Mass, decorated with fine paintings.

This painting was part of a huge altarpiece, ordered and paid for by a wealthy family for their parish church in Florence. Other panels of the altarpiece show different scenes from the life of Jesus. It was meant to help people concentrate on their prayers, and it must have made a splendid sight in the dark church, as all the gold decoration glittered and glowed in the candlelight.

You can see how patterns were punched into the golden haloes, using special metal punching tools, to catch the light.

The diagram (right) shows how all the different parts of the altarpiece probably fitted together. The Coronation was the most important part, so it belonged right in the middle. Most of this altarpiece is in the National Gallery.

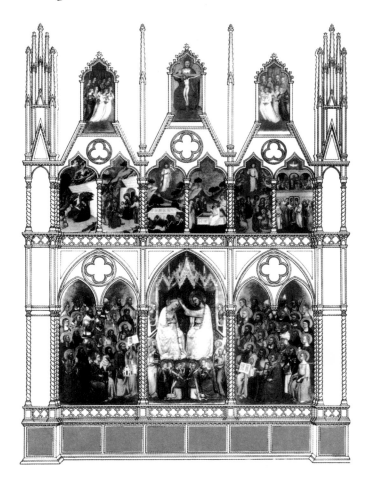

What's going on?

The Virgin Mary is being crowned Queen of Heaven by her son, Jesus Christ. Saints and angels are watching, some playing musical instruments. On the left panel (below), Saint Peter holds a model of the church for which the altarpiece was painted.

Making the painting

This altarpiece was taller than several people, standing one on top of the other. Making it was a complicated business, involving lots of different craftsmen. The wood panels were cut to shape and the edges carved to make a frame. The bare wood had to be covered with layers of glue, fine linen and a kind of whitewash, called gesso, to make it ready for painting on. Gold coins were beaten out into sheets as thin as tissue paper, laid side by side for the areas of gold. Only when all this work was complete could the painting begin.

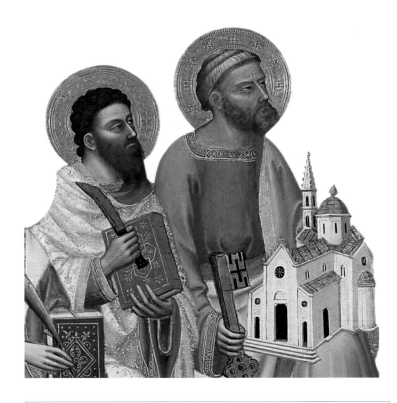

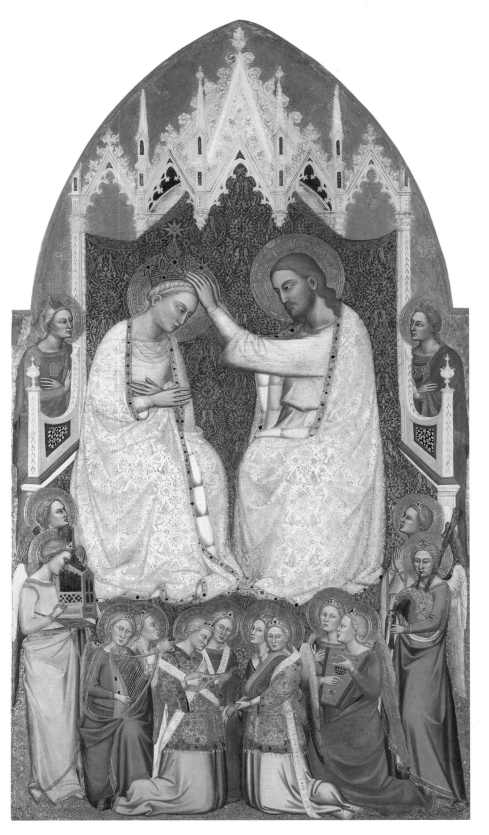

The Coronation of the Virgin
Probably painted by Jacopo di Cione, an Italian artist working in Florence between about 1362 and 1400, and his workshop. The altarpiece was painted in about 1370–1. This panel is about 206 cm high and 113 cm wide (81 × 45 inches).

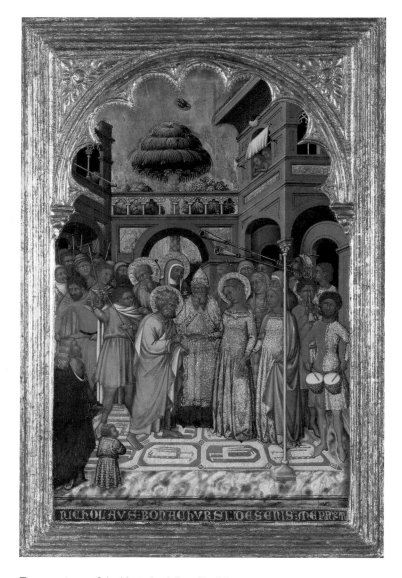

The marriage of the Virgin by Niccolò di Buonaccorso

For the painting, Jacopo di Cione used egg tempera – powdered colours mixed with egg yolk. The patron – the person who had ordered the altarpiece – drew up a contract with the painter setting out the subject, the size and the price, the amount of gold to be used and the quality of the colours. There was to be no cheating with cheap materials!

Religious pictures could be good business. One fourteenth-century Italian merchant ordered a job lot to be sold abroad: 'Let there be in the centre Our Lord on the Cross, or Our Lady, whichever you can find – I do not care so long as the figures are handsome and large, the best and the finest you can buy, and the cost no more than 5½ or 6½ florins.'

On your knees

People also liked to have religious paintings in their homes to help them concentrate on their prayers. This little painting (left) shows the Virgin Mary marrying Saint Joseph. The artist made three panels altogether, each showing a different scene from the Virgin's life. It is a small picture, and we can be fairly sure that it was made for private use by one person, kneeling, because it was obviously meant to be seen close to. The artist wrote his name on it in Latin, which was the language all educated people wrote in.

NICHOLAUS BONACHVRSI DE SENIS ME P[I]NX[I]T

Niccolò di Buonaccorso of Siena painted me

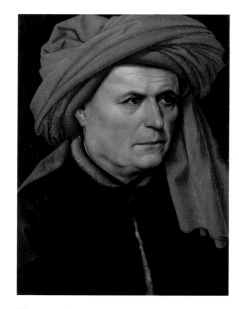
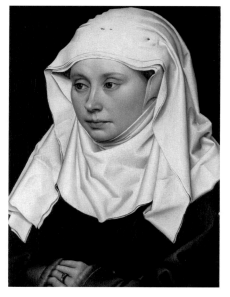

A man by Robert Campin
A woman by Robert Campin

Portraits

Not all paintings of this time were of religious subjects. These two portraits, showing a husband and wife, were painted in the early fifteenth century. We do not know their names, but from the fancy headdresses and their fur-lined clothes we can guess that they were quite well-off.

A king to admire

Some portraits were made to be seen in great public rooms, such as this huge life-size picture of Charles l, King of England. It was originally hung in the royal palace at Hampton Court.

In real life, Charles was very short and not very handsome, but he wanted this portrait to make him look impressive. The artist, Van Dyck, shows him astride his horse (there really were big horses with little heads like this), with a faraway look in his eye. Charles, a noble king in shining armour, is ready for battle in defence of his kingdom. He chose to have himself painted high above our eye level. Like the servant holding the helmet, we must look up to him from below. The King was not as secure as he wanted to appear in this portrait. The country was heading towards civil war and in the end Charles lost the war, his kingdom and his head.

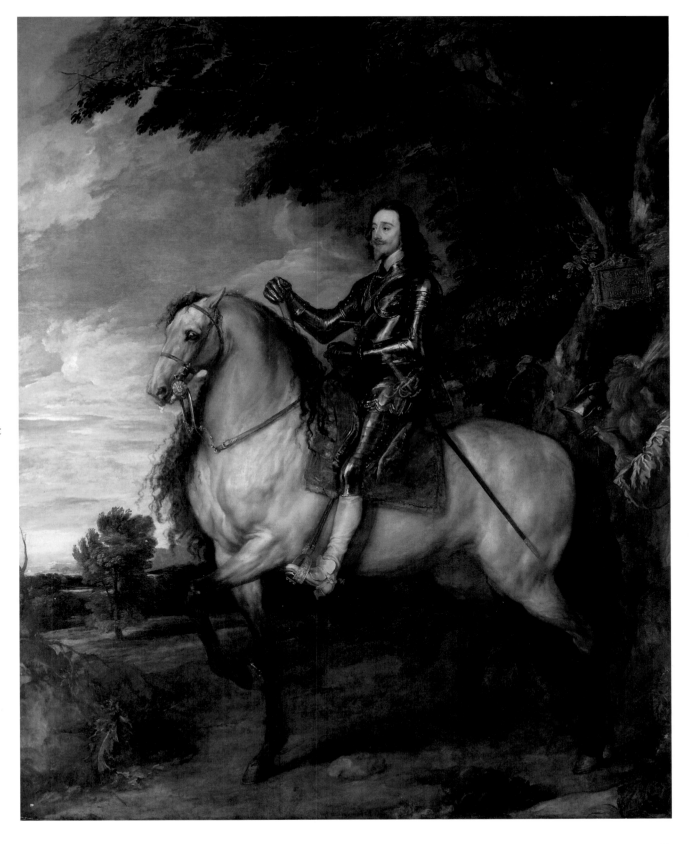

Equestrian portrait of Charles I
by Anthony van Dyck

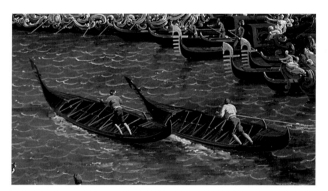

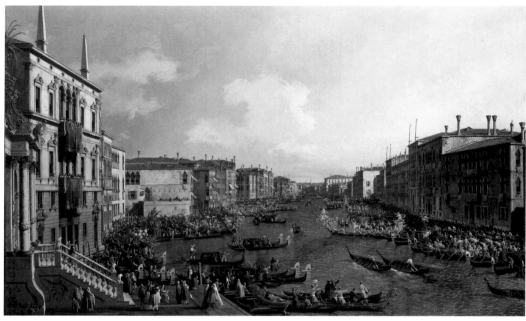

Venice: a regatta on the Grand Canal by Canaletto and (above), detail of gondolas racing.

Wish you were here

Canaletto lived in Venice in the eighteenth century. Wealthy English tourists were fascinated by the city, with its elegant buildings, canals and gondolas. When they returned home (no photos or postcards in those days), a painting by Canaletto was the perfect souvenir. However this painting is not a snapshot. It was put together from several views and sketches. And it is not just a souvenir of a place, but also a record of a special event – a regatta, or boat race.

Decorating the walls

There are quite a few 'pictures in pictures' in this book. You can see some hanging on walls, but there is also a painting on an easel, and one with its back to you.

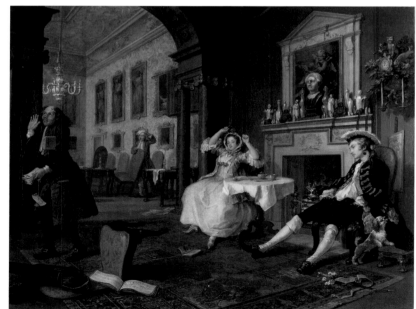

Nowadays we can decorate rooms easily and cheaply with posters. In Hogarth's time, people who could afford it collected paintings to hang on the walls of their grand houses.

Marriage à-la-mode: the tête à tête by William Hogarth

Night-time investigation

When Pissarro painted this picture of Paris by night, he did not intend it for anyone in particular. Although he probably hoped someone would want to buy it later, the subject interested him. He enjoyed painting city scenes and he returned to the Boulevard Montmartre again and again to paint it in various weathers and in different lights.

Other artists were also fascinated by how appearances can change, with the light, the weather and the time of day. (Look at the pictures by Turner and Monet, on page 57, for example.) Pissarro had never painted a night-time scene before, so it was a new challenge. He captured the effect of gas and paraffin lights in the darkness, reflected on the wet pavements. He painted this view from the window of a room on the top floor of an hotel.

Pissarro sold his paintings through art dealers, but some of his pictures were unpopular at first. He carried on experimenting whether people liked his work or not.

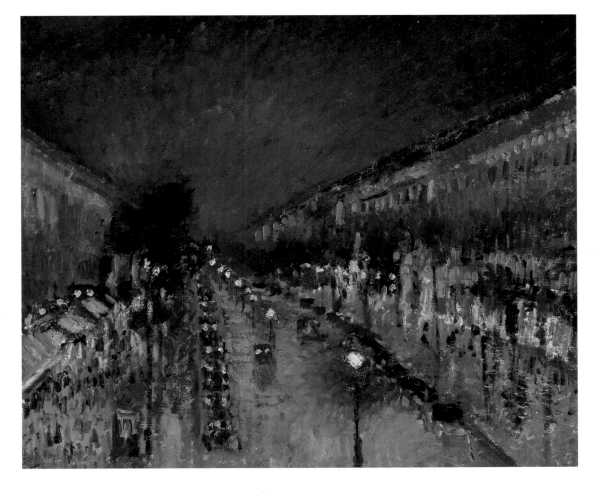

The Boulevard Montmartre at night by Camille Pissarro

TELLING A STORY

Saint George and the dragon
by **Paolo Uccello**

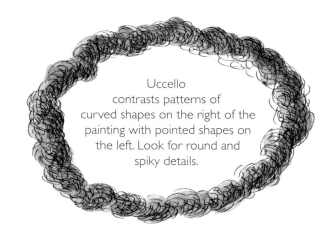

Uccello contrasts patterns of curved shapes on the right of the painting with pointed shapes on the left. Look for round and spiky details.

When we read something dramatic like that, we all picture it differently.

Artists do the same. Uccello gives this story a strange magical setting, as if it were being acted out on stage. He creates a stormy backdrop, builds a cave as if from papier mâché, and plants the ground in curious patches.

Uccello liked playing with shapes and colours to create patterns on the canvas. Spiralling clouds and bubbly treetops echo the round shapes in Saint George's armour. Red and white colours link the princess and the horse on either side of the murky dragon.

Uccello's idea of a dragon was a knobbly two-legged creature with a corkscrew tail and targets on its wings, to inhabit his strange story world. This modern poem imagines what the dragon thought of Uccello's portrait.

Not my best side, I'm afraid.
The artist didn't give me a chance to
Pose properly, and as you can see,
Poor chap, he had this obsession with
Triangles, so he left off two of my
Feet. I didn't comment at the time
(What, after all, are two feet
To a monster?) but afterwards
I was sorry for the bad publicity.

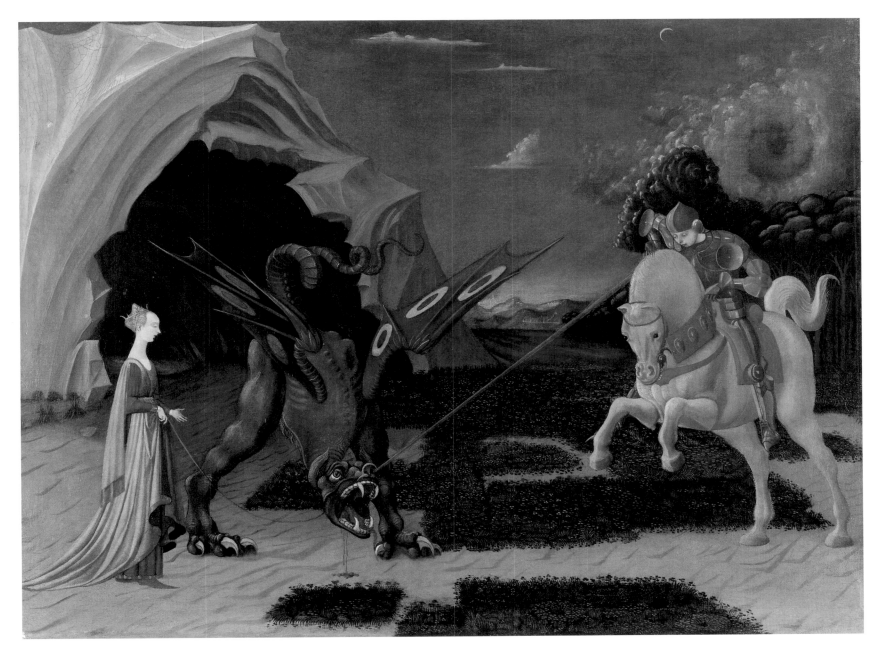

What's going on?

According to an ancient legend, a terrifying dragon which fed only on human flesh demanded a regular supply of victims from the nearby city. One day it was the turn of the king's beautiful daughter to be sacrificed – but just in time Saint George came riding to the rescue.

There are many paintings of this popular and dramatic story (three in the National Gallery alone) and some of them are quite grisly. In this version Saint George has wounded the dragon with his lance, but hasn't yet killed it.

On the right Saint George is thundering into the attack. On the left, the calm princess already has the dragon on a lead.

Saint George and the dragon
Painted by Paolo Uccello, an Italian artist working in Florence. He was born in 1397 and died in 1475. The picture was painted in about 1470. It is 55 cm high and 74 cm wide (22 × 29 inches).

23

Look out for rabbits! Although the story is a dramatic one, even the most important events take place with normal life going on around them.

All sorts of stories

Paintings often tell stories. They may show religious stories from the Bible, dramatic tales from history, the lives of saints, or myths and legends from ancient Greece and Rome.

Many church pictures were painted at a time when most people could not read, so they were an important reminder of the Bible stories they heard from the pulpit. The myths painted for educated people were better known in the past than they are today. But painters also borrowed ideas from other paintings, some of them made long before their own lifetime.

While you were asleep...

Mantegna's painting, below, illustrates the Bible story of how Jesus, knowing his death was near, went into the countryside outside Jerusalem to pray. There he is, kneeling on the rock. His closest friends, who are meant to be supporting him, are sound asleep and snoring. Judas, another of his followers, has turned traitor. He is leading out of the city a long line of soldiers to arrest Jesus.

Mantegna brings all these parts of the story together, shaping the scene amongst towering rocks and along the path which you can see snaking into the distance. On the left, angels are showing Jesus a cross, and other objects of his Crucifixion, a reminder that his death is soon to come.

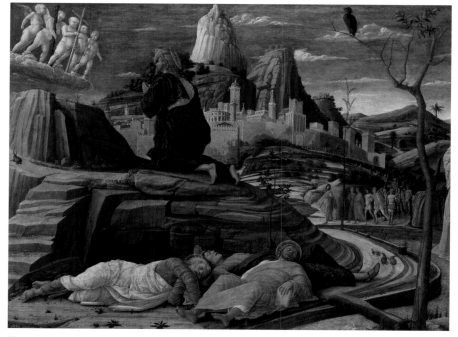

The Agony in the garden by Andrea Mantegna

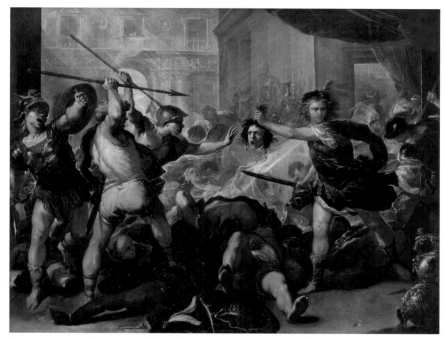

Perseus turning Phineas and his followers to stone by Luca Giordano

If you're interested in the stories which lie behind some of these pictures, you may also want to find out more about how different artists treated the same subjects.

Frozen to the spot

Some pictures give the impression that we are witnessing an actual event. This painting by Luca Giordano tells the story of a most extraordinary wedding feast! Perseus the bridegroom is being attacked by jealous Phineas (on the left, wearing a helmet) and his men. Perseus (wearing blue) stops them in their tracks by holding up the head of Medusa, a snake-haired Gorgon. This turns all who see it to stone. Perseus is careful not to look himself, but his enemies are doomed. The grey stone creeps down their flesh, freezing them to the spot, arms still outstretched.

This is a huge painting, as large as a football goal. Yet Giordano completed all his paintings at great speed, often watched by an audience. He was even nicknamed 'Luca fa presto' (Does-it-fast Luke).

A tragic story

The painting on the right is based on an historical event. Lady Jane Grey was Queen of England for just nine days in 1553, after the death of King Edward VI, but Mary, Edward's sister, had a better claim, and soon won the throne; Lady Jane's head was cut off. She was only 16 years old. This painting was made nearly 300 years later, in 1833. Dramatic stories like this were always in fashion, and Delaroche set out to stir people's feelings. The real execution took place outdoors, but he paints Lady Jane Grey as if on a stage with a spotlight focused on her. He uses the pure white dress, the blindfold and the outstretched hands to draw out our sympathy for the young, innocent victim.

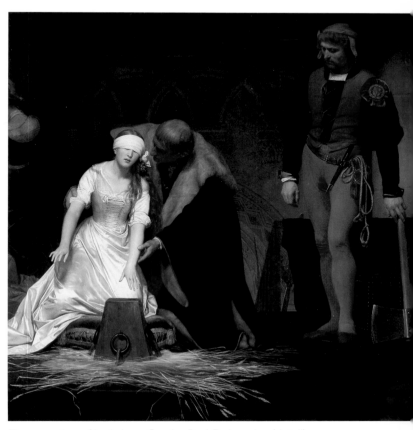

The execution of Lady Jane Grey by Paul Delaroche (detail)

HIDDEN MEANINGS

The Arnolfini portrait
by **Jan van Eyck**

Looking at this picture we almost feel that we have stepped into the room with the man and woman who stand holding hands. They are probably Giovanni Arnolfini, an Italian merchant living in Bruges, and his wife.

The people might look rather strange, but the objects in their room seem quite ordinary. There is a shiny brass chandelier with a single lighted candle. Cast-off shoes lie on the floor, and the couple's dog stands in front of them. On the wall behind them we can see a circular mirror, a string of rosary beads, and a brush.

At the time this was painted, people would have been amazed at how real it all looked. But it is possible that van Eyck also intended these objects to have other meanings. Dogs, obedient and loyal, could represent faithfulness. The shoes may have a religious significance – people take off their shoes when entering some holy places. Around the mirror are tiny scenes from the life of Christ, and perhaps this and the mirror itself are reminders of God's presence.

What's going on?

Five hundred years after this picture was painted, we are puzzled by it. Perhaps we are witnesses at some private ceremony. Is it a wedding? We cannot be sure.

If you peer into the mirror you can see the reflection of two mystery figures looking in on the couple through the open door. Could one be van Eyck himself, without his paintbrushes? The bold signature on the wall announces

Johannes van Eyck fuit hic 1434
(Jan van Eyck was here 1434)

To us, the lady looks pregnant. In fact, round stomachs were in fashion then, and her skirts are adding to the bulge.

Van Eyck's meanings may puzzle, but his painting is crystal clear. The tiniest details look marvellously real, like these glass beads. You can even see their shadow on the wall.

Making the painting

Van Eyck painted this picture with oil paint, on an oak panel. Oil dries slowly so the artist had time to blend and smooth brushstrokes in the still-wet paint, sometimes using his fingers. With some colours, oil paint is more transparent than egg tempera, and van Eyck was able to use translucent layers, called glazes, to build up realistic-looking dark shadows and folds of cloth.

It has been said that van Eyck 'invented' oil painting. We now know that this is not true, but he understood perfectly how to use it.

The Arnolfini portrait
Painted by Jan van Eyck, a Netherlandish artist who worked from about 1422 to 1441. This picture was painted in about 1434. It is 82 cm high and 60 cm wide (32 x 24 inches).

If you have never seen this sign before, it does not take much thinking about to guess the meaning!

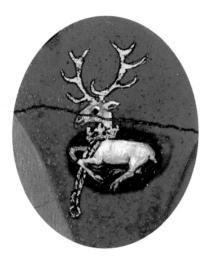

The white hart, King Richard II's royal emblem

Dogs and doves were quite common in fifteenth-century paintings. You'll find at least two more in this book.

Spot the symbol

In van Eyck's time, artists often included symbolic objects in paintings. A symbol is something which has a special meaning, or message. Symbols might include fruits, flowers, birds, animals or household objects. In a marriage scene, the dog might be a symbol of faithfulness, because dogs are obedient and faithful animals. In religious pictures a dove might represent the Holy Spirit. People recognised religious symbols and their meanings as well as we understand the symbols used today on roadsigns for schools or one-way streets.

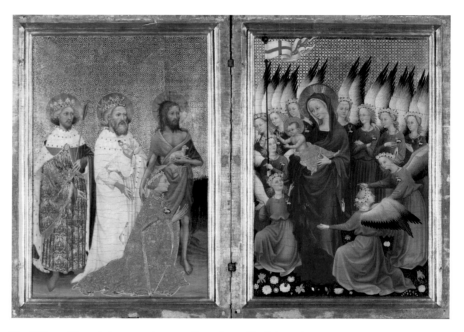

The Wilton Diptych by an unknown French or English artist

Royal signs

Badges, like uniforms, can show who people are and which group they belong to. In 1390 Richard II, King of England chose a deer, the white hart, as his royal emblem. It appears all over this folding altarpiece which shows off Richard's royalty and claims God on his side. Angels cluster round, as if for a team photograph, each one sporting a white hart badge. Richard has the finest badge of all.

The colours in paintings can have meanings too. Here Mary and the angels are dressed in blue, the colour of heaven. This rich shade of blue, made from precious lapis lazuli, was very expensive. Using all this blue and gold made the painting fit for a king, and for God.

ROSES

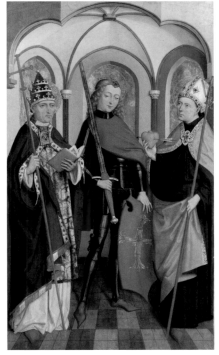

Saints Gregory, Maurice and Augustine

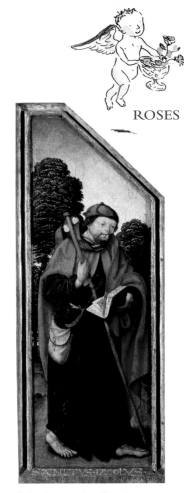

Saint James the Great

KEYS

SACRED HEART

COCKLE SHELLS

LION

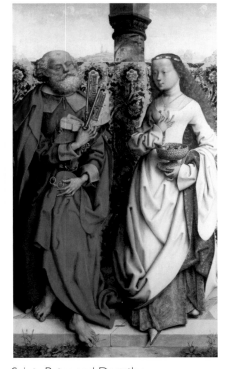

Saints Peter and Dorothy

Saint Cecilia

Saint spotting

If you're going to meet someone who doesn't know what you look like, you might say that you will be carrying a book or wearing a red jacket. This helps to identify you. In the same way, painters show saints with some special object from the saint's life story. These objects, called attributes, help you to recognise who's who.

We've illustrated the attributes associated with six saints. Five of them can be seen on this page. The sixth attribute is from a picture elsewhere in this book – perhaps you can find it.

ORGAN

LAYER UPON LAYER

Tobias and the Angel
by workshop of **Andrea del Verrocchio**

This painting is like sweet music for the eyes.
Tobias and the angel are almost dancing along.

Tobias's cloak rhymes with the angel's wings. Can you see how
hands, arms, legs and sashes echo each other, as if singing a musical
round? There are paired patches of red and blue, and glimpses of
silver river on each side, to complete the harmony.

What's going on?

Young Tobias was on a journey to collect money owed to
his blind father. On the way he was joined by the Archangel
Raphael, who helped him catch a fish and take out its insides
to use as a cure for his father's blindness. Tobias carries the
gutted fish, and the rolled list of debts, while Raphael holds
the miraculous medicine.

This story comes from the Apocrypha, an appendix to the
Bible. When artists paint stories from the past, they often set
them in their own times. Here the landscape, curly hair and
fine embroidered clothes all belong, like the artist himself,
to fifteenth-century Italy.

Making the painting

Verrocchio was the master of a famous painting and sculpture
workshop in the Italian city of Florence. The members of
his workshop included apprentices and trained assistants. We
cannot be sure how many of them had a hand in this painting.
'Tobias and the angel' was painted on a panel of poplar wood.
Verrocchio, or a member of his workshop, would have made
an exact drawing to mark out the area of each colour. Look
how precisely Raphael's legs have been painted in. The artist
used egg tempera, which dried fast. Very thin layers of paint
had to be built up carefully on top of each other to produce
the shading of skin, and the light and dark folds of cloth.

The fingers on the angel's hand do not quite fit the folds they
are meant to be holding up. You can see that Tobias's left hand is
almost exactly the same as the angel's. Both hands probably came
from a collection of drawings in the workshop, which could
easily be copied by a young apprentice. This was one way an
artist could save himself work.

Tobias and the angel by workshop of Verrocchio (detail)

Look at the see-through dog at the
angel's feet. Over hundreds
of years, the white paint
has become transparent where
it was thinnest. You can now see right
through the remaining
curls to the path beneath.

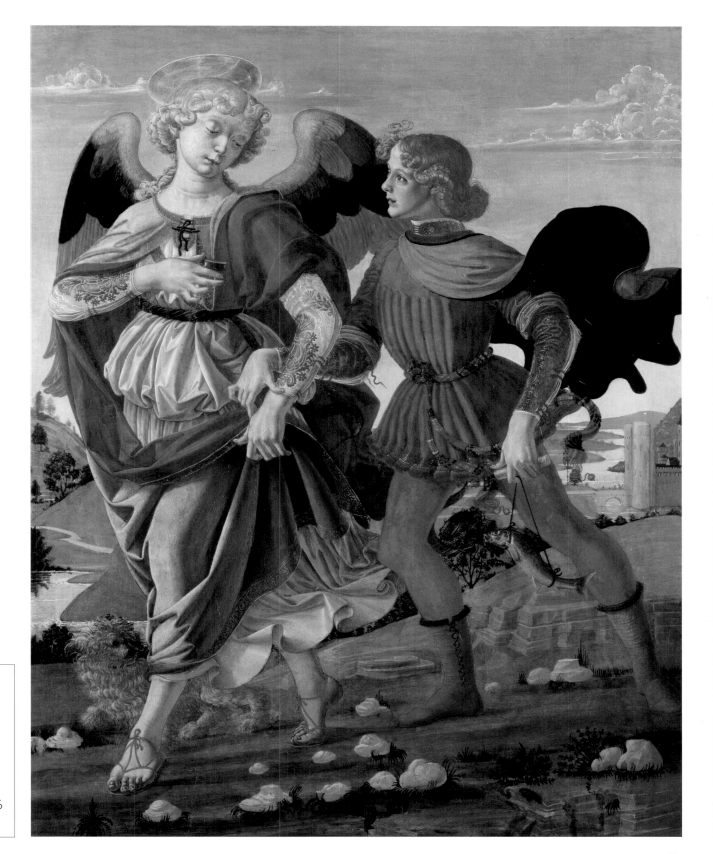

Tobias and the angel
Probably painted by the workshop of Andrea del Verrocchio, an Italian artist who worked in Florence. He lived from about 1435 until 1488. This picture was painted between 1470 and 1480. It is 84 cm high and 66 cm wide (33 × 24 inches).

Beneath the surface

There is much more to a painting than meets the eye. The paint itself may be barely a fingernail thick but it can contain many layers. Each layer of paint adds to the effect, but most are hidden from sight in the finished painting.

Painting on wood

Until the early sixteenth century, most moveable pictures were painted on wood panels. Artists used whatever was available – in Italy, usually poplar wood, and in northern Europe, oak. Artists went to a lot of trouble to prepare their materials for painting. Planks of wood were joined together to make a smooth panel. Sometimes a frame was carved out of the panel or fitted to it at this stage, before painting began.

To prevent the paint from soaking straight into the wood, the artist sealed the surface with glue, made from animal skins and bones. Then he had to apply a foundation layer all over it called the 'ground'. This gave a smooth surface and a good base colour for painting on.

In the picture on the left, Saint Luke, the patron saint of artists, is shown working on a framed panel painting propped up on an easel.

Painting on canvas

Fine linen canvas was often glued onto wood panels before the ground was applied. This strengthened the panel and helped to hide any faults. Later, painters also used this woven canvas cloth on its own. Canvas needed no carpentry. It was lighter than wood and could be rolled up and carried around. By 1500 more and more paintings were being made on canvas.

Canvas is fastened over a wooden framework called a stretcher. This stretches out the canvas surface and keeps it flat and taut so that the artist can paint on it.

Cézanne gives us a back-to-front view of a canvas on its wooden stretcher, propped up in his studio. By the time he painted this in the 1860s, artists could buy canvases and paints ready-made, instead of having to prepare them themselves. Nowadays, art shops have a huge choice of ready-made painting materials.

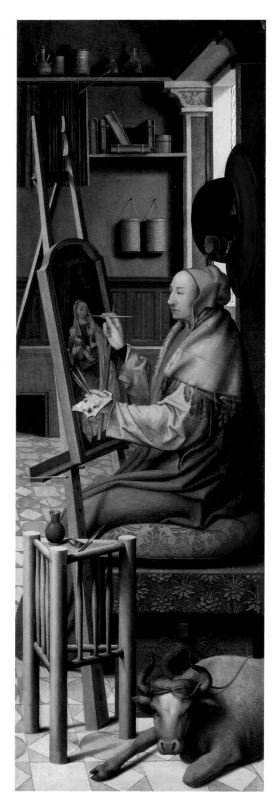

Saint Luke painting the Virgin and Child by a follower of Quinten Massys

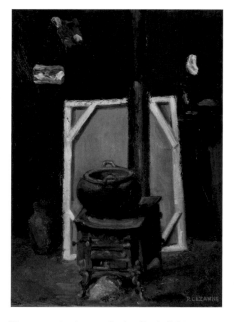

The stove in the studio by Paul Cézanne

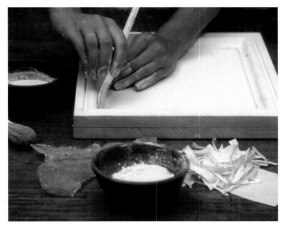

Brushing gesso onto a panel.

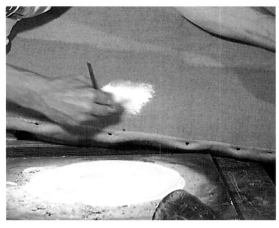

Preparing a canvas. You can see how it is nailed to the stretcher.

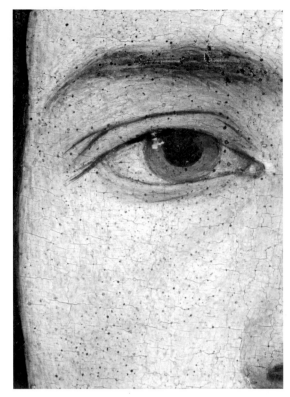

Portrait of a young man by Sandro Botticelli (detail), during restoration

Preparing the ground

On most wood panels, and in the sixteenth century on many canvases, the ground was made from a white powdered mineral cooked with glue. The recipe used in Italy made a ground called 'gesso'. In northern Europe, the mixture was made with chalk. It was smoothed on in layers like runny plaster. When it was dry it could be polished to a brilliant white, smooth surface, like ivory, ready for drawing and painting.

The gesso or chalk and glue mixture had to be made very carefully. Too much glue could result in cracks. If the gesso was allowed to boil, or stirred too vigorously, you got air bubbles. In this painting by Botticelli (right) you can see black spots where bubbles in the dried gesso have burst, making pock marks appear.

Light and dark

The white ground of 'Tobias and the angel' reflects light back through the paint layers, making the colours glow. Later artists like Rembrandt often preferred to cover their canvases with a coloured layer of grey or orangey-brown, before they started painting. The artist could use this colour to help him, working with lighter and darker colours on top and sometimes letting the brown underneath show through. You can see the difference this makes if you try painting on coloured paper rather than on white.

This is a small area of a painting by Rembrandt, 'A woman bathing in a stream'. He used just a few brushstrokes of white and dark paint, leaving the light brown ground layer in the middle, unpainted.

Making drawings

In a workshop like Verrocchio's, artists spent a lot of time studying hands, feet, faces or draperies and making drawings which might be used later. Drawings were made in chalk, charcoal or ink, or using a metal point. Graphite pencils, the kind we have today, came into use about 200 years ago.

In the sixteenth century, artists often made a full-size drawing as a guide for painting. This was called a cartoon, from the Italian word meaning 'big paper' – not 'a joke'! The drawing could be transferred direct to the painting surface by scoring lines into the soft plaster or gesso.

Another method was 'pouncing'. Holes were pricked along the lines of the drawing. It was then placed on top of the gesso and powdered charcoal was dusted over it. Black powder fell through the holes making dots on the gesso. These dots were then joined up to make an accurate copy of the drawing. This is how Raphael made his little painting 'Vision of a knight'. The original drawing has survived and the painting matches it exactly. You can even see the holes along the lines of the drawing.

Painting in progress

Michelangelo worked as painter, sculptor and architect in sixteenth-century Florence and Rome. In the detail of this unfinished painting you can see how he built up layers of paint to make the final effect. On the left there is still bare white gesso with lines drawn on it. He has blocked in green paint as an undercoat for areas of skin. In the finished painting, the green would just look like shadows in the skin. A greenish tinge still shows through thin layers of flesh colour, making Mary look quite seasick. Which parts do you think look more finished?

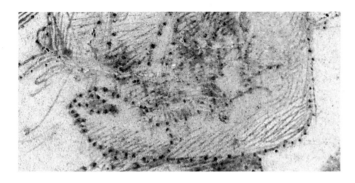

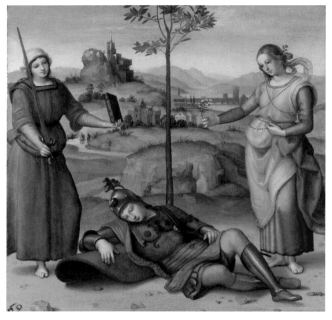

Vision of a knight by Raphael. Drawing (top, detail) showing the holes for the charcoal dust, and (below) the painting.

The Manchester Madonna by Michelangelo (below)

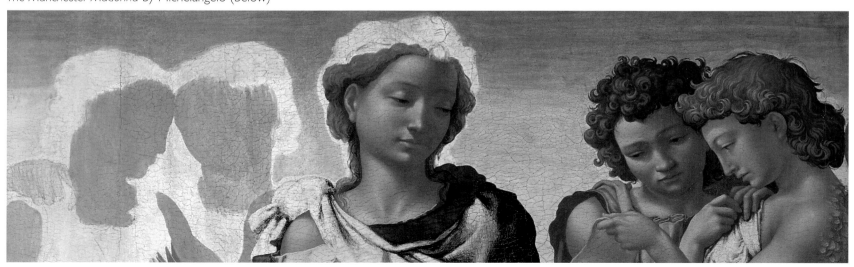

34

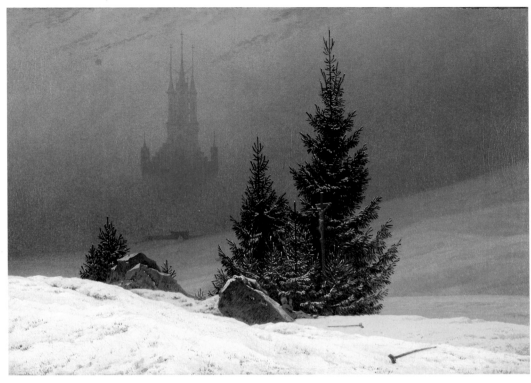

Winter landscape by Caspar David Friedrich

Detail showing the removal of discoloured varnish from the painting. You can see what a difference this made to the colours.

The paint layer

By the fifteenth century, painters were using both egg tempera and oil paint. At first this did not much affect the way they painted, which was really a method of colouring in precise drawings. Using fast-drying egg, artists had to work quickly; they couldn't vary the finished effect very much, and paintings in tempera generally look light and bright. Later, artists found that slow-drying oil paints gave them much more freedom, allowing them to paint both in a thick, brushy way (look at the Rembrandt on page 53), and in thin translucent layers. Dark colours could also be made to look deeper and more intense. Gradually, oil painting became the most popular technique. You can read more about how paint is made on page 38.

On the surface

Paintings today don't look exactly as the artist intended. They change over the years, and sometimes they are hidden by a layer of varnish. Varnish protects the paint but it can turn yellow-brown with age and this dulls the colours. When this snowy landscape painting came to the gallery it was covered with a darkened varnish layer. When the old varnish was removed, you could see that the mist was really pink!

While the painting was being cleaned, infrared examination revealed that underneath there is a detailed drawing in pencil and ink.

This infrared image shows Friedrich's scribbly drawing underneath the paint layers, and where he's made changes to the man's feet.

FOCUS ON COLOUR

The skiff
by **Pierre-Auguste Renoir**

What colour is water? Renoir knew that its appearance changes endlessly with the light.

Here the river is a deep blue, because the water is reflecting a blue sky. Reflections of people, boats and buildings cast their own colours into the river. The flickering surface scatters the light and splinters the reflections, breaking up the colours. The river becomes a kaleidoscope of mixing, merging colour fragments.

Renoir was once one of a group of French painters, including Monet and Pissarro, who came to be known as the Impressionists. They painted their impressions of how things looked, working in the open air to catch the changing effects of light on the colours around them. Monet wrote 'When you go out to paint, try to forget what objects you have before you, a tree, a house, a field or whatever. Merely think here is a little square of blue, here an oblong of pink, here a streak of yellow, and paint it just as it looks to you…'

Making the painting

Until the eighteenth century, artists prepared their own paints in the workshop or studio. Later, artists could buy machine-made oil paints, and from the 1840s these were available in easy-to-use, squeezy metal tubes, much the same as the ones we can buy now. This made painting outdoors much simpler.

Renoir used just eight colours to capture this colourful scene. He did not mix the paint much, but laid brushstrokes of pure colour beside each other. You can see this very clearly in close up, although from a distance the colours seem to merge together.

Renoir carried on painting outdoors right up to the end of his life.

Renoir was interested in the way that colours react with each other. Blue and orange, red and green or yellow and purple are known as complementary colours. They look extra bright when seen alongside each other. Renoir uses pure unmixed blue and orange together to give the feeling of a dazzling, sunny day.

The skiff by Renoir (detail) showing individual brushstrokes of pure colour.

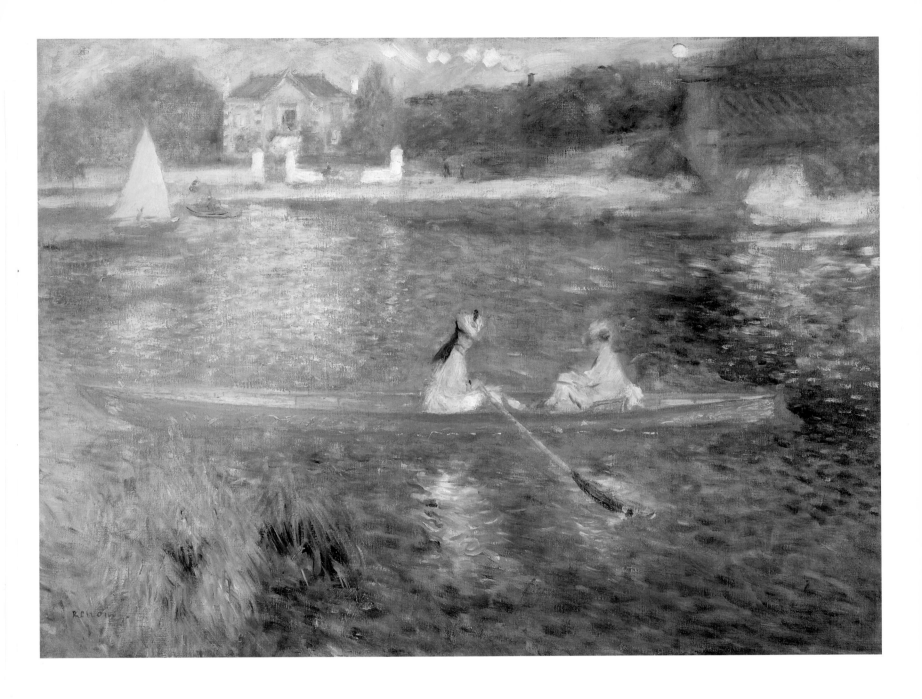

What's going on?

The ladies on the boat are enjoying themselves on the River Seine, not far from Paris, just over 100 years ago. Behind them you can see a train steaming over a metal bridge on its way into the city. People liked to get out at the weekends to relax by the river, gossip with friends and go boating or bathing, just as they do today.

Renoir and the Impressionists liked painting water and people enjoying themselves, so the river bank was a favourite painting place.

The skiff
Painted by Pierre-Auguste Renoir, a French artist, who was born in 1841 and died in 1919.
This picture was painted in 1875. It is 71 cm high and 92 cm wide (28 × 36 inches).

Most of the blue, including the sky, is painted in natural **ultramarine**.

Bacchus's flying cloak is painted in **crimson lake**.

The sea is painted with **azurite**, a natural mineral which provided a greeny-blue pigment.

Ariadne's sash is **vermilion**, a bright orangey-red pigment manufactured from sulphur and mercury.

The drapery near Ariadne's feet is painted in **lead-tin yellow**, made from lead and tin oxides. Titian did not have the strong, brilliant yellows manufactured today.

There was no single bright green pigment in Titian's time, so he used mixtures. In the trees on the right, he mixed ultramarine with white and finished off with a transparent glaze made with **verdigris**.

For the bright green by Bacchus's right leg, Titian used greeny-blue **malachite** and **azurite**. Although the verdigris glaze has turned brown with age, the malachite underneath still looks green.

Renoir admired Titian's use of colour. He even joked that Titian – painting 300 years before him! – was 'forever stealing my tricks'. Ariadne's sash and Renoir's boat share one colour trick – blue and orange-red together make each other look brighter.

Pigments and paint

Paint is made up of a coloured powder, or *pigment*, mixed with a liquid binder, or *medium*.

Pigments can be extracted from plants, insects, earth or minerals or they can be manufactured from metals. Then they are ground to a powder and mixed with a medium such as glue, egg or linseed oil to make paint.

Paint made by mixing a pigment with egg looks different from paint made by mixing the same pigment with oil, and it also behaves quite differently. Egg tempera dries quickly, so the artist has to work fast with small, precise brushstrokes. Oil paint is slow drying, so the painter has time to draw out long brushstrokes. He can push the paint around, paint thickly or thinly, or change his mind and paint one colour over another even before the first layer is dry. Being able to do this affected the kind of pictures artists produced.

Titian's colours

Titian worked in Venice in the sixteenth century, using oil paint. The dry pigments were ground and mixed with oil on a stone slab in his workshop. This had to be very carefully carried out to produce the right quality of paint. Grinding some pigments too much or too little could spoil the colour.

As Venice was the centre of the pigment trade, Titian could choose from the most brilliant and best quality pigments. 'Bacchus and Ariadne', a painting made for a very wealthy patron, gave him a chance to show off with strong and exciting colours. Scientists have examined this painting and identified Titian's pigments (left).

Obtaining pigments

Some pigments were quite cheap and easy to obtain. Others were rare and expensive.

Crimson lakes were sometimes made from a substance produced by the lac insect, a kind of beetle found on trees in India and the Far East.

Orpiment (yellow) and **realgar** (red) were quite unusual pigments mostly used by Venetian painters. They were made from arsenic sulphides, and extremely poisonous. In this painting, Titian used them for the orange dress of the Bacchante (the lady with the cymbals).

Verdigris is a blue-green pigment produced by the action of acetic acid on copper. You can make some yourself by leaving a real copper coin in a dish of vinegar.

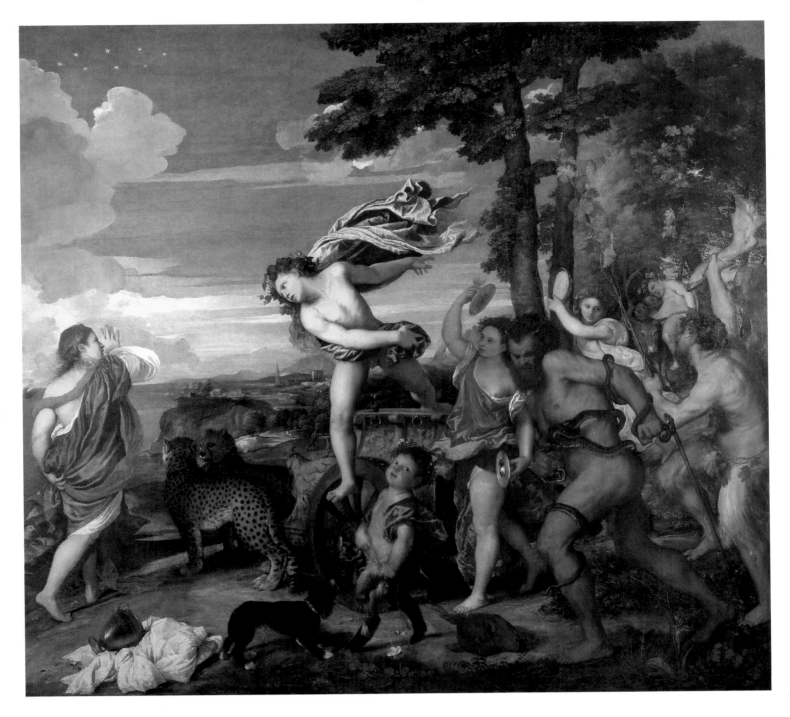

Bacchus and Ariadne by Titian

Ultramarine was made from lapis lazuli, a mineral imported from Afghanistan. It was so rare that ultramarine was more expensive than gold. Nowadays, lapis lazuli is mostly used for jewellery.

Earths of different colours provided cheap browns, red and yellows, similar to those found in cave paintings – you can find coloured earths yourself in some parts of the country.

Lead white was used on its own and mixed with other colours. This was a very common pigment manufactured from metal. It shows up clearly in X-rays.

Carbon black could be made from soot, charred wood or burnt bones. There is not much pure black in this painting.

A regatta on the Grand Canal by Canaletto (detail)

Moody blues

For centuries, blue was a problem for painters. Both ultramarine, made from the precious mineral lapis lazuli, and azurite, were expensive and often in short supply. Then in the eighteenth century a German colour-maker produced a completely new blue by accident, while trying to make red. This intense colour, Prussian blue, was the first truly synthetic pigment. Canaletto used it, mixed with white, to paint the bright blue skies over Venice.

Early in the nineteenth century, chemists discovered how to make artificial ultramarine. This cost 700 times less than the natural pigment, and it was immediately put into use by the ceramics industry. At around the same time, scientific discovery of the metals chromium and cobalt made available other man-made blues, greens and yellows. When Renoir painted his river with cobalt blue, he was free to explore the world in full colour.

Concentrating on colour

For Monet, there was nothing more exciting than colour. He painted the lily pond in his garden at Giverny countless times, in different lights, searching out every fleeting colour effect. Working at his easel outdoors, he mixed and matched the colours from his paint tubes to what he saw dancing before his eyes.

Here he captures the mauve afternoon light. Look at the array of colours he finds in shady places and in among the flowers on the water.

The water-lily pond by Claude Monet
(above, detail)

Colour feelings

Van Gogh did not try to copy colours just as he saw them. '… instead of trying to reproduce exactly what I have before my eyes, I use colour… to express myself forcibly.' Colours can make us feel cheerful or gloomy, peaceful or excited. Van Gogh had strong feelings and he used colour in his own way to express these feelings in his paintings.

This chair was in Van Gogh's house. You can see his pipe and tobacco on the rush seat. The chair is Van Gogh's favourite bright yellow. Like many people, he found yellow cheering, hopeful and warm, like the sunshine of Provence where he lived and worked. He outlines the yellow with blue to give a daytime feeling. Van Gogh sets the chair against a blue door and wall and strong red tiles. The colours help to make the simple stocky chair stand out boldly.

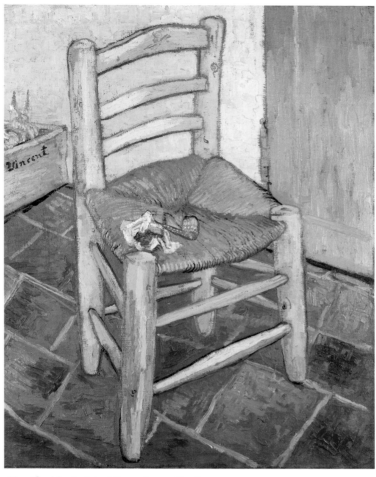

Van Gogh's chair by Vincent van Gogh

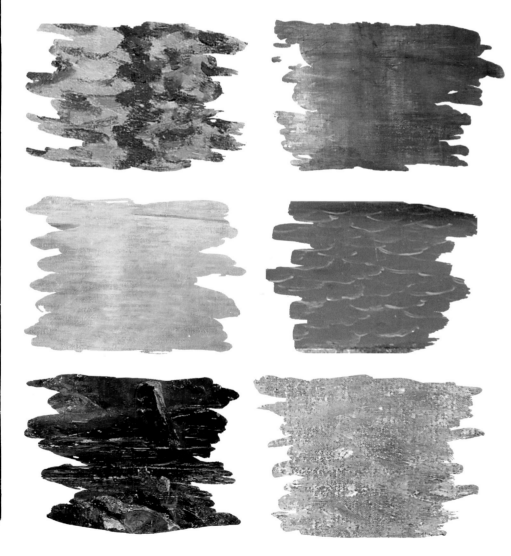

What colour is water? These watery details show a variety of artists' answers. Look through this book to find the paintings they come from. Search the sky and the surroundings in each painting to find what is giving the water its colour.

Crivelli enjoyed making every detail look perfectly real. He shows you the grain in the wood, the barbs in the feathers, and mortar dripping from new brickwork on the far wall. The marrow looks real enough to tumble out of the painting!

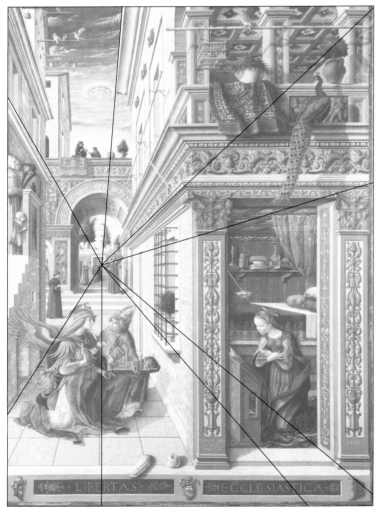

TRICKING THE EYE

The Annunciation, with Saint Emidius
by **Carlo Crivelli**

When we look at paintings we know we are seeing a flat, painted surface.

But Crivelli makes us believe that we could step inside the picture, walk along the street, and enter the buildings. The angel looks close enough for us to join in the conversation. The people on the bridge are smaller, so they look much further away.

Crivelli makes a flat painting look three-dimensional by using perspective. This is a way of making painted objects look solid, and showing how far away they are meant to be.

What's going on?

March 25 was a special day for the people of Ascoli Piceno in Italy. It was the feast day to celebrate the Annunciation, when the Angel Gabriel told Mary that she would be the mother of Jesus. It was also the day on which the Pope had given the town the right to set up its own government.

Crivelli linked the two events in this painting for a church altar. He shows the Annunciation taking place among fine buildings of his own time. Heavenly light beams down on Mary, as the Holy Spirit visits her in the form of a dove. Emidius, the patron saint of Ascoli, interrupts Gabriel to show him a model of the town. It must have been rather inconvenient for the angel in the middle of delivering such an important message to Mary! Other people are carrying on as normal.

Points of view

In the real world, if you walk down a street or round a house, the view changes with every step. Crivelli chose to paint his Annunciation as if seen from the end of the street, with eyes on a level with the window in the far wall. Imagine yourself standing in this position. The diagram on the left shows how Crivelli worked out all the perspective from this single viewpoint. He makes lines above eye level lead down into the distance. He makes lines below eye level lead up. All these lines, if they went back far enough, would meet at the window opposite your eyes.

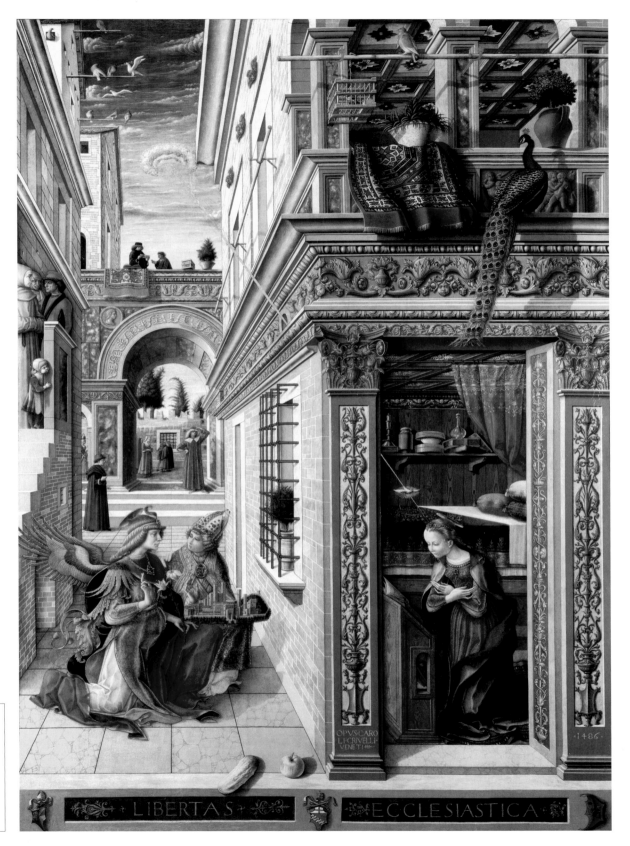

The Annunciation, with Saint Emidius
Painted by Carlo Crivelli, an Italian artist working in Ascoli Piceno. He was born in the 1430s and died in about 1494. This picture was painted in about 1486. It is 207 cm high and 147 cm wide (81 × 58 inches).

Special effects

Painters can conjure up crowds of people, spacious buildings and faraway hills, all in thin layers of paint. To do this, they use special effects to imitate the way things look in the real world and make your eyes believe what they see.

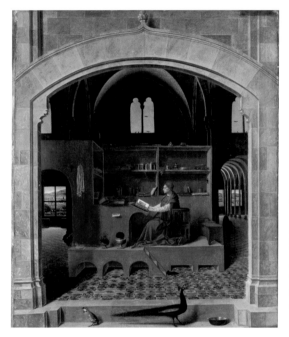

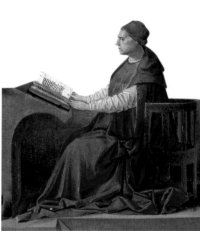

Saint Jerome in his study
by Antonello da Messina

Through the window

Many paintings have windows or doorways to frame the view and tempt your eyes into the world beyond. Here you can stop and gaze in at Saint Jerome in his study. The painting even seems to beckon you to climb the sunlit step, creep round Saint Jerome and look out of the back windows towards the distant hills. (Watch out for the lion in the shadows.) The open doorway, the arches and the windows all draw you deeper into the painting.

Shaped by light

When light shines on a box or a bowl, it does not light it evenly. Painters use the way light falls to make objects look solid and real, with sides and corners and curves. Antonello uses light and dark to shape the wooden platform, and the shiny bowl on the step.

Robes and rich materials catch the light as they fall in folds. Artists paint fabric by copying these light effects with their paintbrushes. Jerome's cloak is red all over, but each fold is rounded out with light and dark tones.

A peepshow with views of the interior of a Dutch house
by Samuel van Hoogstraten

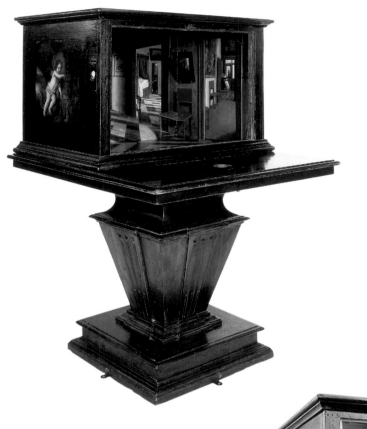

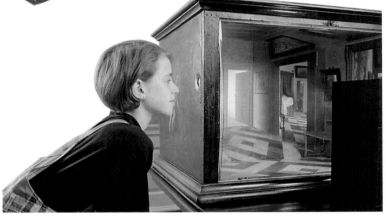

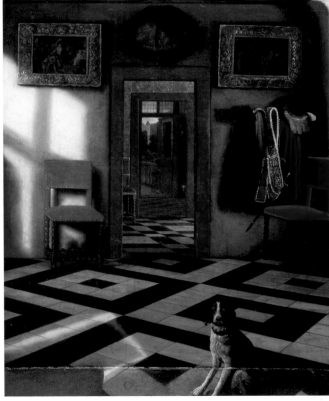

Peepshow

In the seventeenth century, Hoogstraten played with perspective to make this peepshow. He painted the inside walls of a box to make it look like a Dutch house. When you peep with one eye, through a hole at either end, you can see across the tiled floor into room after room. Hoogstraten even worked out how to paint the dog along the floor and up the wall so that it sits up like a real dog when viewed through the hole.

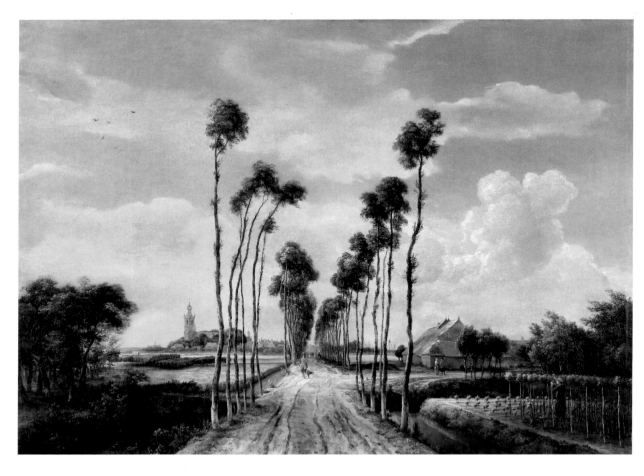

The avenue at Middelharnis
by Meindert Hobbema

POINT OF VIEW
Was Hobbema's avenue seen
like this from up a tree or lying
on the ground? Is this viewpoint on
the road or off to one side?
To check your guess, follow the
edges of the road to where
they meet on the horizon.
That 'vanishing point' makes
us feel we're right in front of it,
walking up the avenue
towards Middelharnis.

Changing sizes

If you bring your hand up to your face, your hand seems to grow bigger
as it comes towards you, just as birds seem to grow smaller as they fly away
from you. Hobbema paints the trees, the houses and the people smaller and
smaller along the road to make them look further away.

Bigger in front

Imagine walking down Hobbema's avenue. Would it take longer to walk
from the first trees to the man with the dog, or from the dog to the people
behind? The second walk would be longer, but Hobbema has had to
draw it shorter to make it look right. This effect is called foreshortening.
Botticelli used the same effect when he painted a horse with its back to
us (far right). It has a big bottom, a small head and nothing to be seen
in between.

Uccello was fascinated by perspective and foreshortening, as you can see
in his picture of 'The battle of San Romano' on the facing page. Look how
he painted the commander's red hat, or the fallen soldier (right). These
look solid and three-dimensional, but unlike Hobbema's picture, Uccello's
has no single vanishing point on the horizon to make the whole picture
space look convincing.

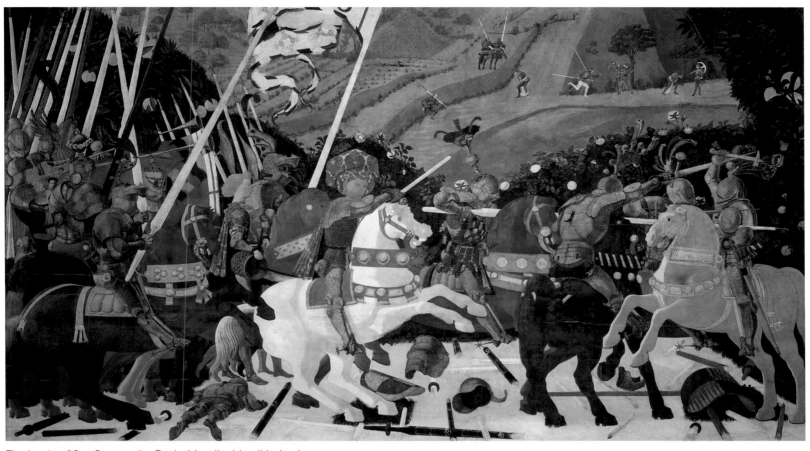

The battle of San Romano by Paolo Uccello (detail below)

The Adoration of the kings by Sandro Botticelli (detail)

The longer you look at a picture like this, the more you can see. There's someone doffing his cap, someone else throwing a snow ball, and another man helping a woman put on her skates. Look out for the hole in the ice!

ORDINARY AND EXTRAORDINARY

A winter scene with skaters near a castle
by **Hendrick Avercamp**

The river has frozen over and people have turned out to enjoy themselves and show off to their neighbours.

Avercamp notices how everyone is dressed, from the humblest to the grandest, down to the last detail. Whatever would it be like skating in a hooped crinoline dress, or in baggy breeches with a ruff round your neck, feathers in your hat and a sword by your side? Take a good look to find out what skates were like around 1600.

There are more than 100 people in the picture, and so much going on that you can't take it all in at once. Everywhere you look there are people stumbling, sliding, dancing, riding, walking around or watching the fun.

Avercamp arranged the scene inside a circle, as if in a glass dome. It looks rather like one of those toy snow-scenes. You can almost imagine shaking it to make snow. Do you feel we are looking in from the flat base, or through the rounded top?

Avercamp could not speak or hear. He lived in a silent world, using his eyes to enter into the life around him and make pictures out of it.

Making the painting

Avercamp filled notebooks with drawings and water-colour sketches when he was out and about, but this painting does not show a real view. He made it up in his studio, piecing it together from drawings and from his imagination.

Look at the colours in the painting. Despite the icy cold, Avercamp makes little use of cool colours such as blue. He prefers to use pink and red, beige and brown. He even warms up the whiteness with a rosy light from the sky.

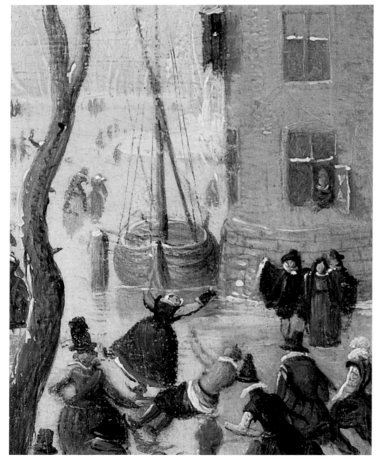

A winter scene with skaters near a castle
Painted by Hendrick Avercamp who was a Dutch artist. He was born in 1585 and died in 1634. This picture was painted in about 1608–9. It is 41 cm (16 inches) in diameter.

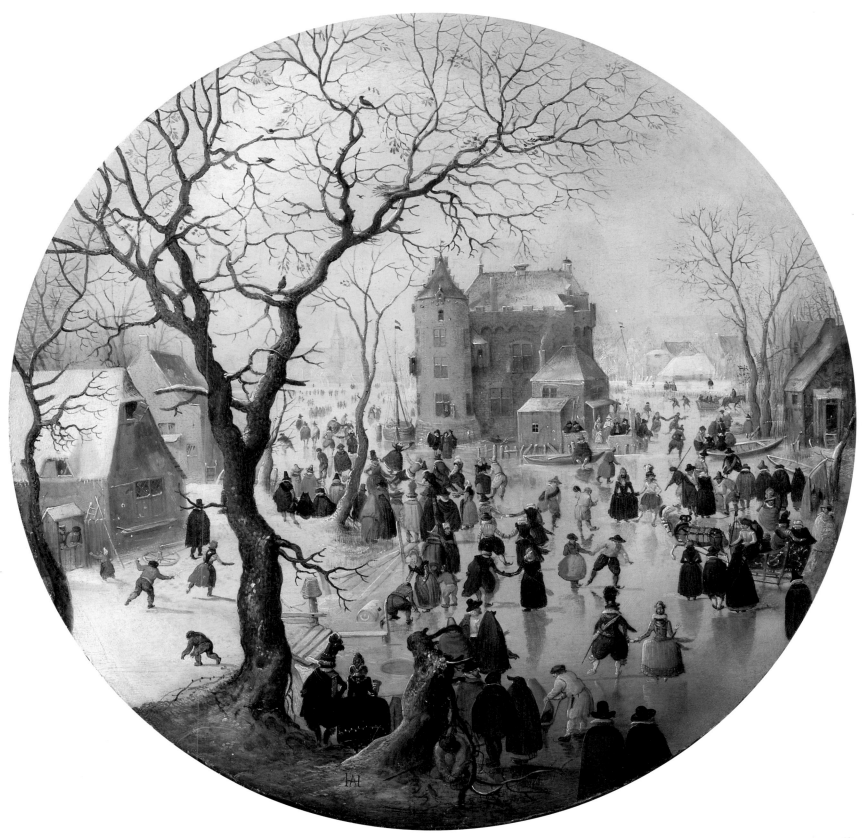

Extraordinary events

The Bible tells us that Jesus was born to Mary in a stable in Bethlehem, and that three wise kings, following a star, came to worship him as the Son of God.

In this lavish painting the artist, Gossaert, has set the stable in the ruins of an old palace. The animals are tucked away in the background. Mary holds her newborn son seated on her lap. You can just see the oxen behind them. Joseph, in red, leaning on a cane, also stands behind.

Before them King Caspar has already offered the Child his gift of gold. King Balthazar, on the left, and King Melchior, waiting on the right, bring precious frankincense and myrrh. They are richly dressed in furs, velvets, and embroidered robes, with elaborate crowns. Caspar has taken off his red and gold hat and laid it on the ground, kneeling bareheaded.

The kings are followed by processions of servants while above, the hosts of angels adore the Child. Shepherds bringing gifts are coming in through the gate behind the Mother and Child.

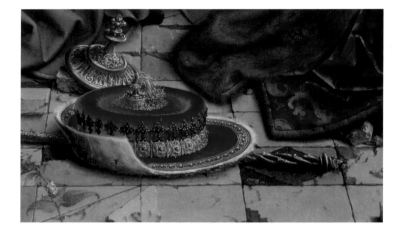

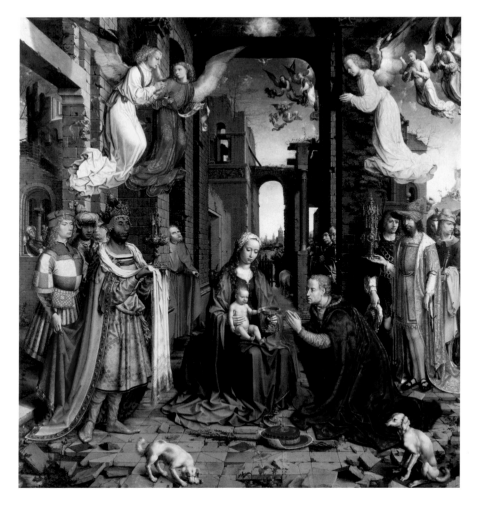

The Adoration of the kings by Jan Gossaert

50

Daily lives

For a long time people believed that great paintings needed grand subjects.

Views of the countryside, the insides of houses or scenes from everyday life, might be included, but they were not worthwhile subjects by themselves.

In the seventeenth century, Dutch painters began to bring the ordinary things of life into the foreground and make whole pictures out of them. Cows grazing, boats sailing, servants working, children playing: all could be turned into paintings.

Close to home

In the picture on the right, de Hooch paints the courtyard of a house, with a lady, a servant and a child going about their daily lives. The Dutch were proud of their homes, their polished furniture, their well-swept tiled floors and their gleaming pots and pans. They believed in hard work, cleanliness and happy homes. De Hooch captures this feeling of contentment, painting each brick and plank with loving care. The broom is a reminder of all the sweeping, washing and tidying which keeps everything in order.

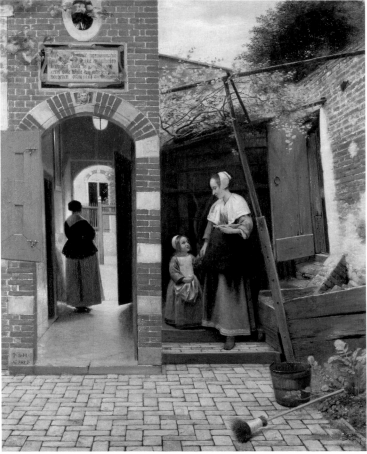

The courtyard of a house in Delft by Pieter de Hooch (right)
Bathers at Asnières by Georges-Pierre Seurat (below)

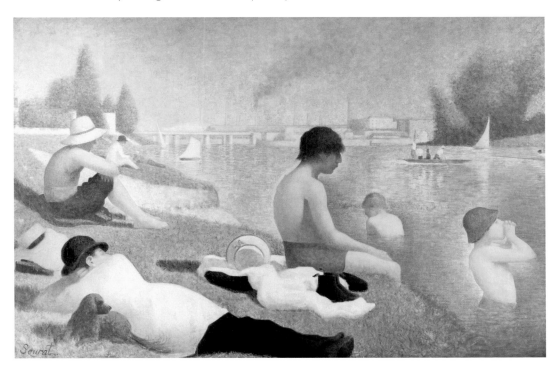

Large as life

People had strong views about the proper size for paintings. By the nineteenth century, pictures of everyday life had become acceptable but they were generally small. Only grand subjects such as mythologies and history painting, or portraits of important people, were expected to be on a grand scale.

This huge picture by Seurat, painted in 1884, broke all the rules about subject and scale. It shows city workers relaxing on their day off by the banks of the River Seine, north-west of Paris. In the background, the factory chimneys billow out smoke. The solidity of the large figures gave them a new importance, and made people look at everyday scenes in a different way.

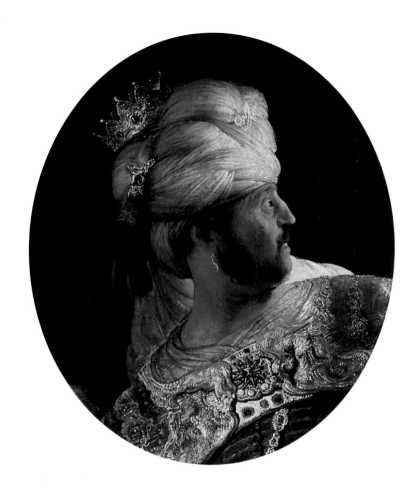

THE POWER OF LIGHT

Belshazzar's feast
by **Rembrandt**

Which part of this painting grabs your attention first?

Most people say 'the man in the middle' or 'that writing'. Quick as a flash, eyes focus on the top right–hand corner, where the man's head and the magic writing are caught in Rembrandt's spotlight.

The dark background makes the gleaming turban and the shining letters stand out. As your eyes move further round the painting, more heads and hands loom out of the night. Gold shimmers. Grapes glisten. Jewels glitter. Rembrandt uses light sparingly. He turns it on where it matters, and leaves the rest in darkness. This all adds to the drama.

The man swings round to watch the hand spelling out its mysterious message. Others look on in alarm. Rembrandt paints people's feelings, not only on their faces, but also in their movements. Here he lights up popping eyes, gaping mouths, wide–flung arms and tense fingers all round the table.

Making the painting

Rembrandt started with a dark paint all over the canvas. Then he built up the deep dark parts of the picture with earthy browns and blacks. He mixed skin colours from yellows, browns and whites. He embroidered Belshazzar's cloak with swirls of thick yellow paint. On top he used pure white paint for the brightest highlights, such as the pearls.

Look for the dabs of brilliant white piercing the darkness on a white feather, black grapes and strings of pearls.

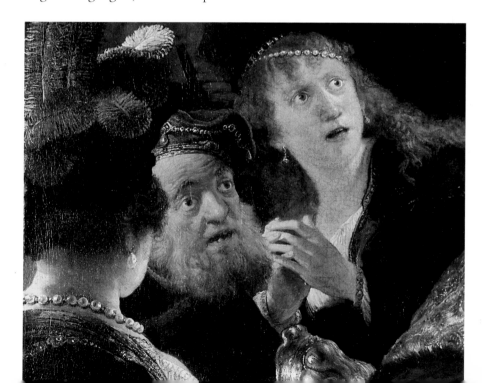

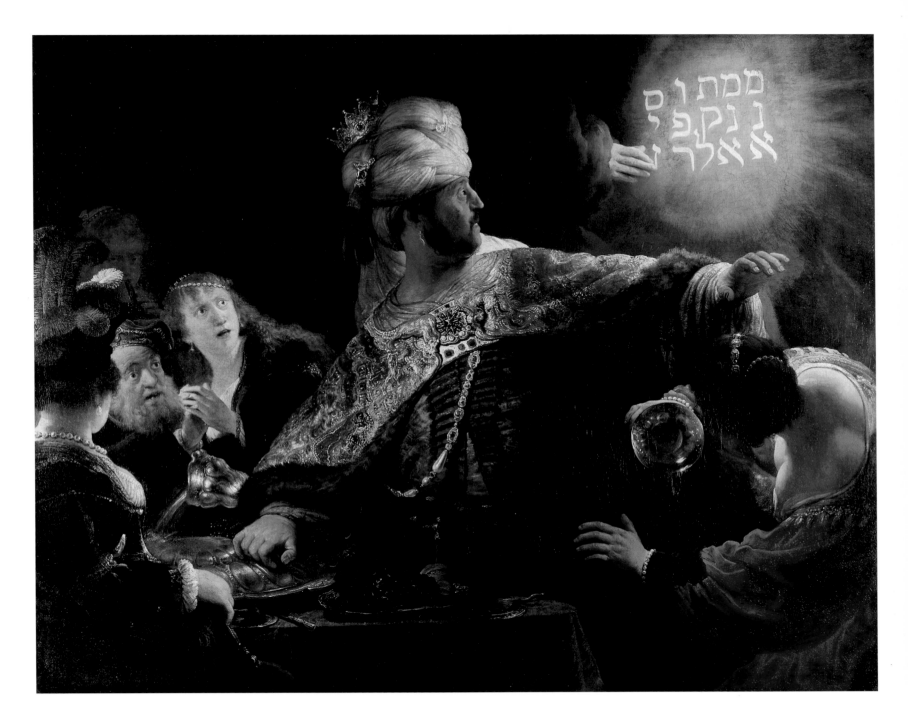

What's going on?

The bible tells the story of a splendid feast, given by Belshazzar, King of Babylon. Belshazzar served the wine in gold and silver vessels stolen from God's temple in Jerusalem. Suddenly he saw a hand moving across the wall, writing a message he could not read. At last Daniel, a wise adviser, told him what it meant. It was a warning that God was angry with him. That very night Belshazzar was killed by his enemies.

Belshazzar's feast
Painted by Rembrandt who was a Dutch artist. He was born in 1606 and died in 1669. This picture was painted in about 1636–8. It is 167 cm high and 209 cm wide (66 × 82 inches).

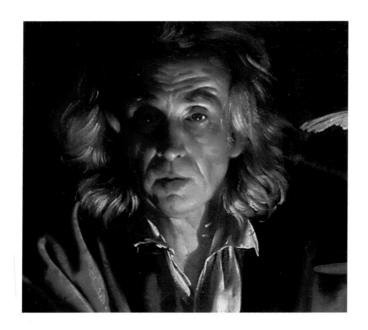

Changing appearances

You cannot see anything unless it has light falling on it.

People's faces, the furniture in rooms, the sea and the sky all need light to show them up. Light changes with the weather and the time of day, so appearances change too. Painters study the way light falls and try to show what they see. They may also play with the light in their paintings, spotlighting what they want you to notice.

Lighting the night

Painters can make a drama from the contrast between light and dark. In Ter Brugghen's painting (below) candlelight throws a strange pattern across the players' sleeves, and softly lights the shadowy faces. The trio seems to form a secret circle, glancing out warily at the audience.

The concert by Hendrick ter Brugghen

You can see from these two photos how lighting the face from below with a powerful torch makes the picture change completely, creating strange and mysterious shadows.

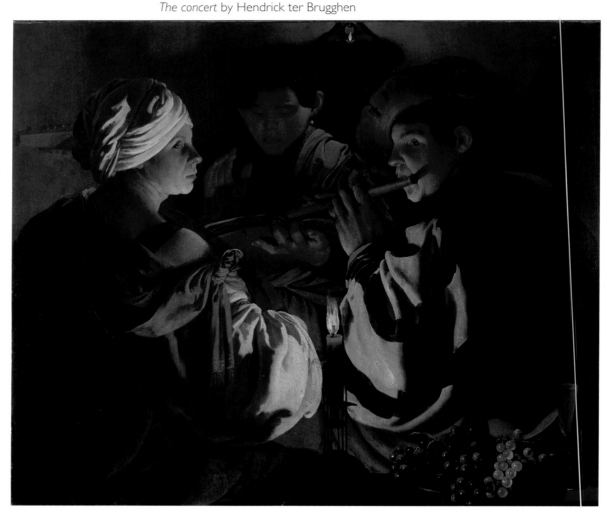

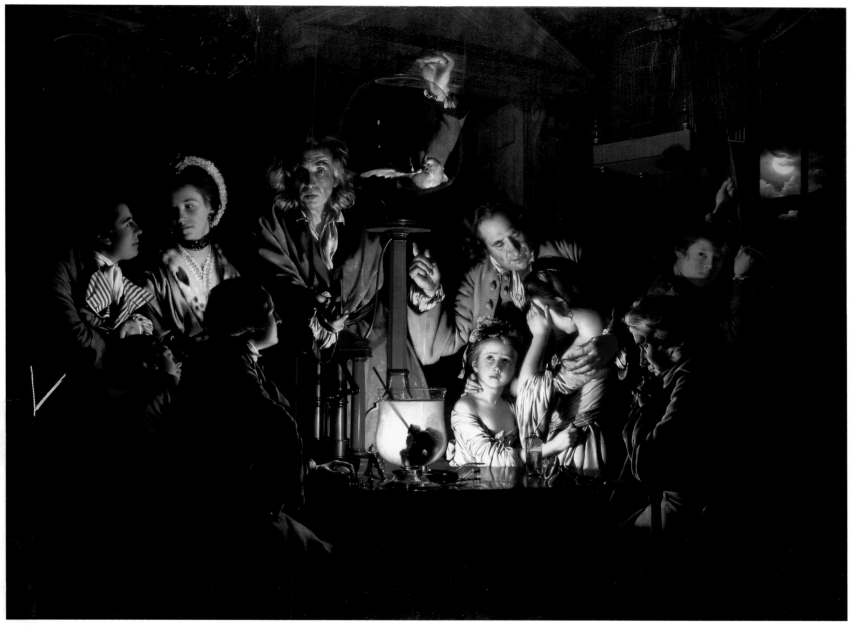

An experiment on a bird in the air-pump by Joseph Wright of Derby (detail opposite, top left)

In the spotlight

In the theatre, darkness focuses your attention on what is happening on stage. Spotlights pick out what is important.

In this painting of a scientific demonstration, Joseph Wright uses light to keep you on the edge of your seat as the drama unfolds. He makes light play on people's faces, revealing their feelings as the scientist pumps the air out of the glass bowl around the bird. Who is interested in the experiment and who is more worried about the bird?

Painters may show where the light is coming from, or they may use hidden spotlights. Look for the light sources in these two paintings, and in 'Belshazzar's feast'.

It's interesting to compare this with other paintings which show light coming in through a window, for example those by Antonello da Messina, p. 44, and Jan van Eyck, p. 27.

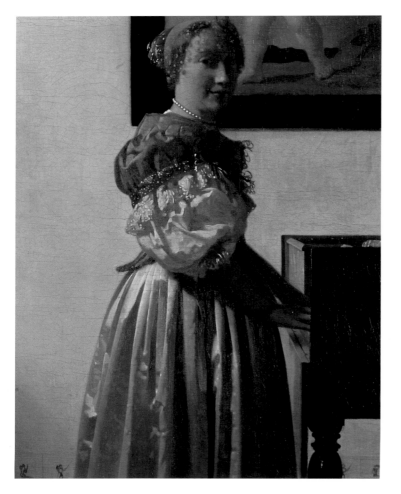

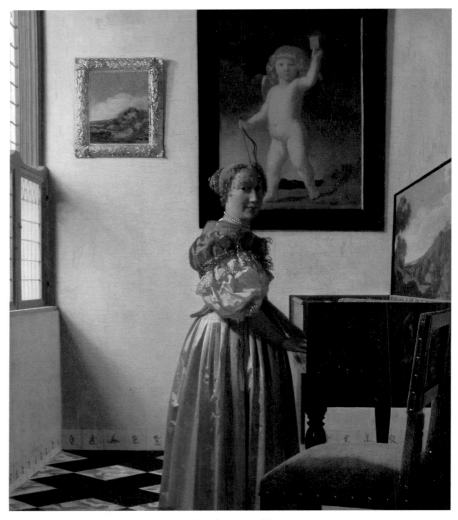

A young woman standing at a virginal by Johannes Vermeer

Daylight

When day dawns, everything seems calmer, less strange and dramatic. Here Vermeer paints a room which is gently lit by daylight filtering through the windows. The way in which he shows the light falling on objects tells us not just what they look like, but also what they feel like, from the silvery lustre of the woman's skirt to the velvety texture of the blue chair seat.

Vermeer focuses on the subtle effects of light and shade. He finely grades the shadows on the wall and lights each fold and crumple in the woman's skirt. He paints an everyday scene in a natural light and shows just how interesting it can be.

Different impressions

Monet often painted the same places again and again. He was fascinated to see how colours altered with the light, producing different effects with different times of day.

This is his impression of the River Thames one spring day. Pink sunlight struggles through the smoggy atmosphere which fades Big Ben to a ghostly finger.

Monet was interested in painting not what he knew was there, but what he actually saw, and he knew that depended on the light.

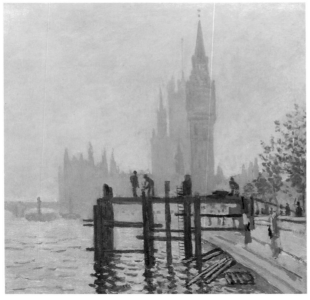

The Thames below Westminster by Claude Monet (detail)

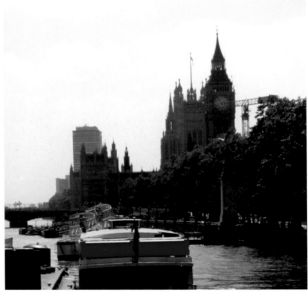

Photograph of the same scene, showing Big Ben as it looks today

Evening light

The 'Fighting Temeraire' had been famous for her courageous action at the Battle of Trafalgar, thirty years before. Turner's picture shows the old ship being towed away by a dumpy modern stream tug, to be broken up.

Turner liked painting the effects of light on steam, smoke, air and water. Sunset reds and golds stripe the clouds, reflect in the water, and even colour the tugboat and its smoke.

Light changes the way things look and how we feel about them. Turner was sorry to see the old battleship go. Here the magnificent sunset gives the painting a sad, proud, goodbye mood.

The Fighting Temeraire tugged to her last berth to be broken up, 1838 by Joseph Mallord William Turner

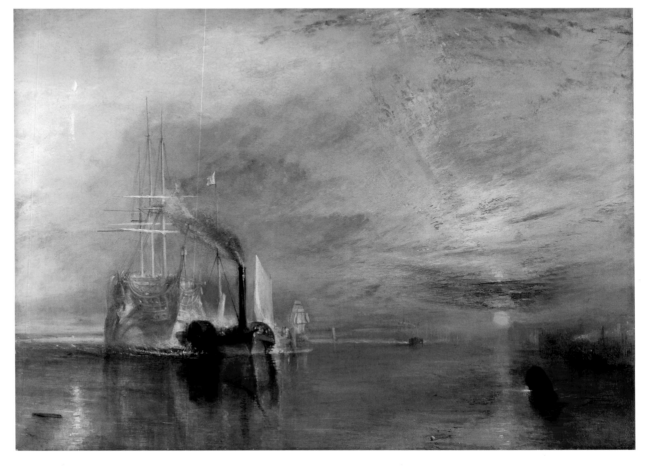

PAINTING PEOPLE

The Graham children
by **William Hogarth**

Most of us find it difficult to keep a smile long enough for a photograph, let alone holding our expression while an artist turns it into paint.

How long can the baby wait before grabbing those cherries?

These children are dressed up in their best clothes which don't look very comfortable. In spite of their angelic smiles they would soon have become bored and fidgety trying to hold these poses. Hogarth must have made separate sketches of the children, which he then put together for the painting.

The oldest girl, Henrietta, looks quite grown up, but she was not yet ten years old when this was painted. She holds the hand of the baby, Thomas, who sits in a pull–along chair. He really is a boy – all babies and toddlers, boys and girls, wore dresses at that time. His brother Richard turns the handle on an organ which plays bird songs. Anna Maria, the younger sister, makes a playful curtsey.

What's going on?

This family portrait also carries a hidden message about childhood. As well as the happy children, there are lots of fruit and flowers in the painting. They stand for life and loveliness, growth and ripening. But take a look at the cat. He has eyes only for the singing bird and is waiting to pounce if he gets a chance. There is a clock in the far corner with a young boy carrying the scythe of Old Father Time as a reminder of death.

The message is that nothing lasts. Life itself can be snatched away. In fact, baby Thomas died even before the picture was completed, but Richard lived to be over eighty and kept this portrait in his house throughout his long life.

Making the painting

The portrait was commissioned by the children's father. It would have taken Hogarth weeks or even months to complete the whole painting. He made drawings, worked out the arrangement, and then put the picture together, filling in the background and doing a lot of work without the children there. Look at the curtain around Richard. Perhaps Hogarth included it to fill an awkward gap, or to make a warm splash of colour in that corner.

The Graham children
Painted by William Hogarth who was an English artist. He was born in 1697 and died in 1764. This picture was painted in 1742. It is 160 cm high and 181 cm wide (63 × 71 inches).

Portrait purposes

Portraits usually do more than simply show what people look like. The sitter may want to be flattered, and shown as beautiful or important.

Or the artist may be interested in exploring character, and telling us what that person was like. Some portraits focus on faces. Others include clothes and possessions and background details to give a fuller picture of the person's life. People often commission portraits to be a lasting reminder of someone special. Paintings live longer than people.

Telling the truth

Dürer's father was seventy years old when this picture was painted. The craggy face seems to have known a lifetime of work and worry. The red background and plain brown cloak lead us straight to the piercing, wary eyes. The artist shows even the mark left by spectacles on the sitter's nose.

The painter's father attributed to Albrecht Dürer

If you didn't know what these paintings were, could you tell which is a portrait and which is a self portrait?

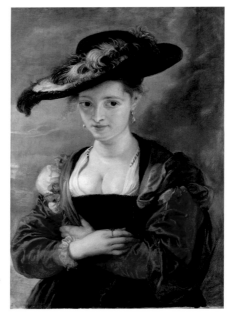

Portrait of Susanna Lunden
by Peter Paul Rubens

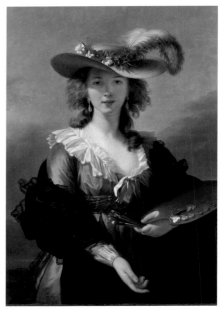

Self portrait in a straw hat
by Elizabeth Vigée Le Brun

Rubens painted Susanna Lunden, who was a relative by marriage, as if out-of-doors. Her wide-brimmed hat partly shades her face from the sun, but light is reflected all around, making even the shadows bright.

A hundred and fifty years later, Elizabeth Vigée Le Brun, a popular French society painter, painted herself in imitation of Rubens's famous portrait. She poses with her artist's palette in her hand, confidently showing herself off both as a woman and as a painter.

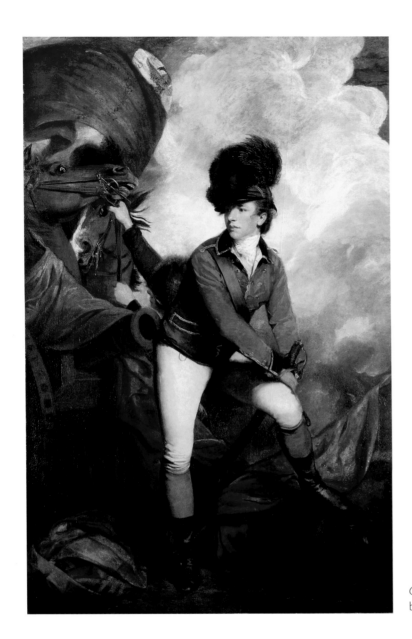

Colonel Banastre Tarleton
by Sir Joshua Reynolds

Action man

Banastre Tarleton was a brave, but vain, English officer who led his cavalry troops into battle in the American War of Independence 200 years ago. This portrait was painted safely in a studio after he came home, not on a battlefield, but everything was arranged to show him as a man of action. He appears to look calmly out into the distance, facing danger with a steady eye. He lost two fingers from his right hand in the war.

Reynolds painted an imaginary background including frightened horses, billowing flags, clouds of smoke and a cannon which looks uncomfortably close. Reynolds did not want the scene to be true to life, but to make the right effect. As he said, '…the painter of genius…often arrives at his end, even by being unnatural.'

Many paintings which are not portraits have people in them. Painters sometimes need models for their characters and often use their family and friends. The faces above all appear in pictures in this book.

STILL LIFE

Fruit and flowers in a terracotta vase
by **Jan van Os**

This painting is so realistic that you feel you could pick a grape and pop it into your mouth.

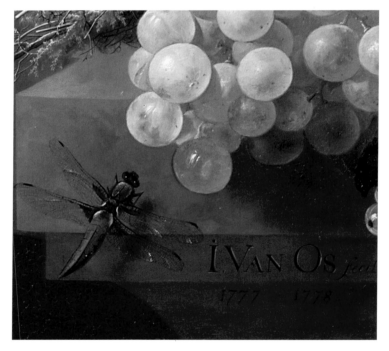

It would be easy to rub the bloom from a plum, feel the softness of the petals or prick yourself on a rose.

The painting of each fruit and flower is as accurate as Van Os could make it, yet the picture is an imaginary creation. The fruits and flowers shown here appear at different times of year and could never be seen all together. Tulips belong to the spring, rosehips to the autumn.

Everything is natural, but nothing is wild. These perfect specimens were the result of good gardening. In Holland where this picture was painted, pineapples were an exotic luxury grown in a hothouse, at vast expense.

Van Os arranged the fruit and flowers very cleverly in his painting, to make it as beautiful as possible. In real life, such an arrangement could not exist. Look at the pineapple. It leads your eye into the top corner, but no flower arranger could ever keep it perched up there. Ancient buildings in the background add to the grand effect. The whole idea is to celebrate the cultivation of nature and the wonder of what can be achieved with paint.

Making the painting

Look at the date. Van Os is pointing out that he had to spread the work over two years, to catch all these fruits and flowers in season. Perhaps he started it in the summer and finished it the following spring. He probably had several paintings like this on the go at once, working on them in turn.

If you look closely among
the fruit and flowers, you'll find
a butterfly • a snail
a fly • a mouse
The longer and harder you look,
the more you'll see.

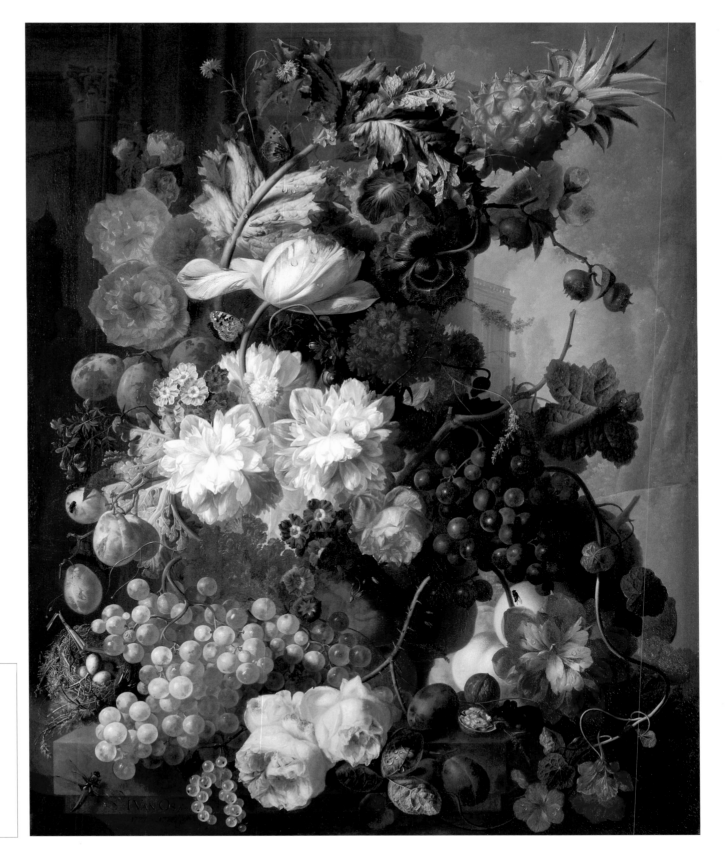

*Fruit and flowers in
a terracotta vase*
Painted by Jan van Os,
a Dutch artist.
He was born in 1744
and died in 1808.
This picture was painted
in 1777–8. It is 89 cm
high and 71 cm wide
(35 × 28 inches).

Interesting objects

Some paintings focus on things rather than on people or places.

If you have ever tried to draw an apple, a plant, a bowl or a bottle you will know just how interesting and complicated even a simple object can be.

In 'still-life' paintings, the artist arranges objects, perhaps food, flowers, tools, or musical instruments, to be the centre of attention. In other pictures, objects add interest or give clues to what is going on.

Puzzling objects

For 400 years or so, people have puzzled over the objects in this portrait. Holbein painted each item in great detail, making them into clues, as if in a treasure hunt.

The top shelf holds a collection of instruments for measuring time and studying the stars. Look for the two sundials: one is a cylinder and one has ten sides. People have managed to work out the date and time from them. It is April 11 and the time is either 9.30 or 10.30. The age of the man on the right is on the book beneath his elbow. He is 25 years old.

The objects give clues to the interests of these clever young men, the ambassador of France to the English court of King Henry VIII and his friend. Yet all their learning cannot hold back the passing of time. This is the meaning of the strange object slashed across the front of the painting. If you look at the painting from the side, at the right angle you can see this shrink to the shape of a skull, which Holbein has stretched and distorted. The skull is a reminder that in the end, death comes to everyone.

The ambassadors by Hans Holbein (details below)

Try looking at this strange shape from the corner of the page.

You can find still-life arrangements in many other paintings. Look at Belshazzar's gold and silver cups and dishes (Rembrandt, p. 53), the objects on Mary's shelf (Crivelli, p. 43), or the Graham children's bowl of fruit (Hogarth, p. 59) — all painted in very different ways.

Still life with oranges and walnuts by Luis Meléndez
Fruit dish, bottle and violin by Pablo Picasso (right)

In the round

Meléndez's oranges (above) are enough to make your mouth water, but the jugs are sealed and the boxes are firmly shut. You are simply invited to enjoy the arrangement of solid shapes, the feel of the textures and the glowing earthy colours.

Meléndez loved painting rounded shapes, even down to the woodworm holes in the table! Look how he used light and shade to bulge the jugs and plump up the oranges. Which direction is the light coming from?

Points of view

By the time Picasso painted this still life (right) in about 1914, painters had long been able to imitate solid objects, true-to-life perspective and changing effects of light. Picasso felt free not to follow the rules. Instead of trying to make objects realistic, he is more interested in making exciting patterns on the surface of the picture. He has even used sand for texture (in the dark brown) and allowed bare canvas to show through. He only gives us hints of which real-life objects these shapes resemble — we have to work this painting out for ourselves. Most people recognise a table and a newspaper, as well as the violin and grapes in a bowl.

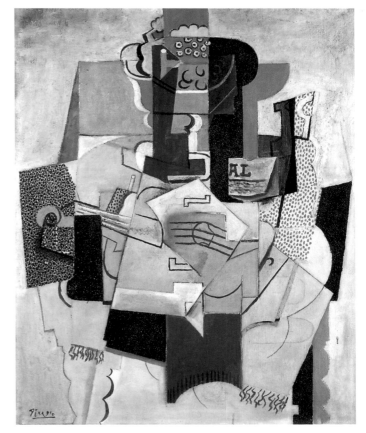

MAGIC LANDSCAPES

The cornfield
by John Constable

Constable loved the countryside in which he grew up.

He did not want to dress it up, turn it into a drama, or use it to fill in the background. He wanted to paint it for its own sake. 'The sound of water escaping from mill dams, willows, old rotten planks, slimy posts and brickwork, I love such things,' he said. 'These scenes made me a painter.'

Constable knew this path well. He had walked along it on his way to school as a boy. He may even have quenched his thirst in the stream like the child you see here. The scene had soaked into his memory.

He loved painting clouds and the way they constantly change the pattern of light on the ground. His aim was to capture a 'brief moment, caught from fleeting time' and make it last for us for ever.

Making the painting
Even when he was painting from nature, Constable took great care in composing his paintings. There is a church straight ahead of you in the distance. Constable invented it to give you something to look towards. Like the tree in the middle of the field, it invites you to look across the cornfield and on into the distance. Try putting your thumbs over the tree and the church. Without them, the cornfield looks like a wall across the painting, bringing your eyes to a halt.

Constable did not sit down at his easel on that rutted path and dash off 'The cornfield' in an afternoon. He first made oil sketches outside, and then slowly put the painting together in his studio, filling in details from these sketches and from drawings made at different times and in different places.

The cornfield draws you to look through the leafy keyhole to the sunshine beyond. Your eyes have to adjust to take in the shady foreground where light filters through the trees.

The cornfield
Painted by John Constable, an English artist who was born in 1776 and died in 1837. This picture was painted in 1826. It is 143 cm high and 122 cm wide (56 × 48 inches).

The Virgin of the rocks by Leonardo da Vinci

Seeing nature

Painters take in the natural world through their eyes, work on it with their imaginations, and draw on what they have seen in other paintings.

The landscapes they paint may be 'real' or made-up. As the view turns into paint it becomes a magical mix of what the artist sees, knows and feels.

Another world

The Virgin is sitting, not on a throne or in a magnificent building, but in a mysterious rocky cavern. Looking past her you can glimpse another world of water, rocks and misty mountains. Leonardo thought of the painter as a creator of worlds. He never stopped looking and drawing, but then he stirred it all up in his mind's eye to make a world no-one had ever seen before.

Eyes on nature

In Leonardo's lifetime, scenes from nature usually appeared only in the background of paintings. Pictures were expected to have more important subjects. This sixteenth-century painting by an unknown artist is different. Here the landscape itself is the focus of attention. The scene is rather like a dream, with pale rocks rearing up from the glassy water, but the detail is realistic. The painter has started by using his eyes to look closely at nature. At the foot of the tall tree (and in the detail on the right) you can seen an artist at work, doing just that.

Landscape: a river among mountains by an unknown Netherlandish artist

A golden view

Claude followed tradition in basing this painting on a story from the Bible, but the story was really an excuse to paint a wonderful landscape. Claude studied the sky, the sea, rivers, hills and trees but when he painted this scene he was not aiming at accuracy. He wanted to create a dreamy, golden view of a perfect, peaceful, long ago time and place.

Two hundred years later, Constable admired Claude's paintings but he wanted to be more true to life. Look at the trees framing Claude's distant view, and those in Constable's cornfield (p.67). How are both artists using them

Landscape with Hagar and the angel
by Claude Lorrain

Can you see how colours grow paler towards the back of the painting? Light seems to hang in the air, misting the far-off hills. Many painters use this fading-out technique for showing distance. Look at each picture on this double page to compare the colours in the foreground with the colour of hills in the background.

A wheatfield, with cypresses by Vincent van Gogh

The way I see it

'Another word for painting is feeling,' said Constable. Van Gogh would certainly have agreed. He felt through his eyes and showed his feelings with his paintbrush. The dark, pointed cypresses fascinated Van Gogh as they brooded over the sunny golden landscape stirred up by the wind. What he saw and the way he felt about it are linked together in this swirling scene.

The little landscapes below can be found in the background of paintings elsewhere in this book. Like still life, they are often found as part of other paintings, not the main subject.

MAKING ARRANGEMENTS

Portrait of Greta Moll
by **Henri Matisse**

Greta Moll was rather shocked at first by the big plump arms Matisse gave her in this painting.

They were not really hers at all. Matisse borrowed them from a painting he had seen in an art gallery, to make this picture look right to him.

Matisse also kept changing the colour of Greta's clothes. At one point she had a lavender-white blouse and a yellowish-green skirt. Then Matisse painted the blouse green and so he had to change the colour of the skirt too. Every time he altered one colour, he had to change the other colours round it, until he found 'a living harmony of tones' which all worked well together.

Matisse liked painting people, but he did not just concentrate on their faces and expressions. Faces and hands were important, but so were the spaces around them. Every corner had to play a part in his arrangement. He kept on changing it until he found the right balance between all the colours, shapes, patterns and sizes. The boldly patterned cloth sets off the oval face. The linked hands make a pleasing shape against the black skirt near the bottom of the canvas. The fat arms and heavy eyebrows help to keep the balance of the painting. Greta Moll said that she soon got used to them.

Making the painting

Although Matisse painted with bold, speedy brush strokes, it often took him a long time to work out the final version of a painting. Greta Moll sat for ten three-hour sessions while Matisse worked on this picture. At last, Matisse knew he had finished. '… a moment comes when … it would be impossible for me to add a stroke to my picture without having to paint it all over again.'

See how different Greta's head looks if you take away the pattern behind it. Look at the red tablecloth in the corner of the painting. Matisse arranged it to balance the blue and white.

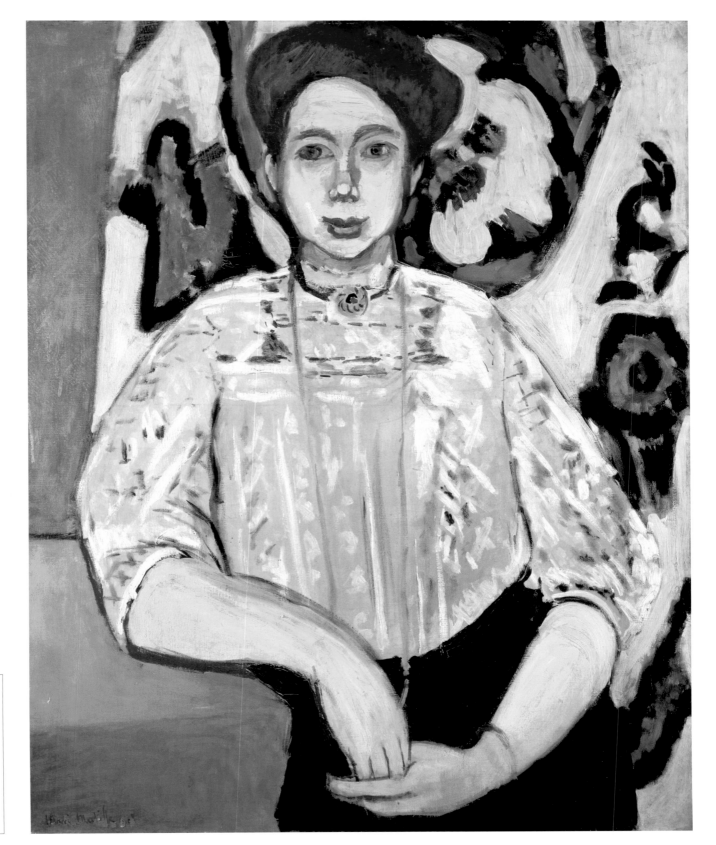

Portrait of Greta Moll
Painted by Henri
Matisse, a French artist
who was born in 1869
and died in 1954.
This picture was painted
in 1908. It is 93 cm high
and 73 cm wide (37 ×
28 inches).

Composing pictures

Painters think hard about how to arrange their paintings. This arrangement is called the composition.

Musical composers work with notes. Painters compose with lines, shapes, colours and patterns. Some painters sort out their master plan before they begin. Others, like Matisse, make decisions as they go along. The composition draws your eyes into the picture and makes the painting satisfying to look at.

Perfect planning

As Saint John baptises Christ, the dove of the Holy Spirit flies down from Heaven. Jesus is the focus of attention. He is in the middle of the painting. Your eyes can run straight down from the dove's beak to Jesus' feet, taking in the trickle of water and the praying hands.

Look how the vertical line of the tree trunk and the horizontal line of the dove's wings section off the painting. This way of dividing up the space was popular in the fifteenth century. It was thought to give perfect proportions which were especially pleasing to the eye.

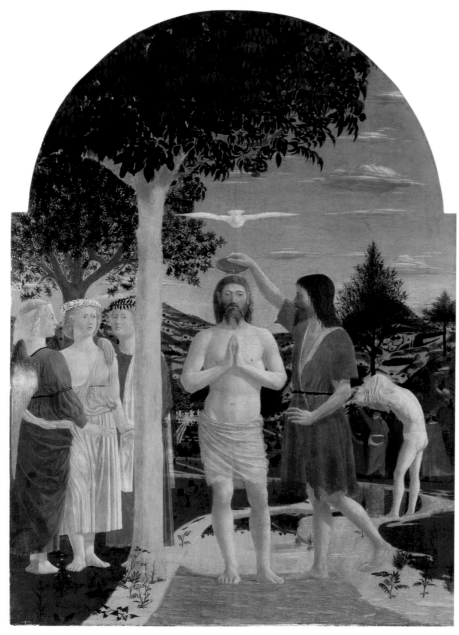

The baptism of Christ by Piero della Francesca

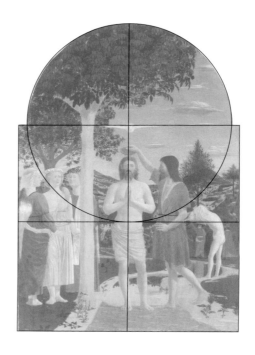

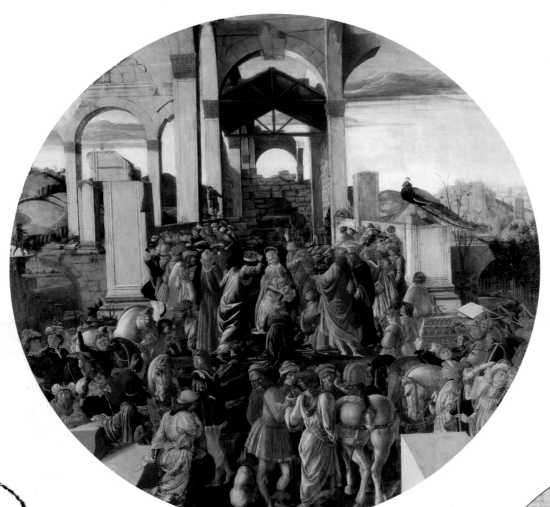

The Adoration of the kings by Sandro Botticelli

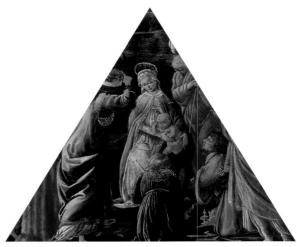

Botticelli's composition draws our eyes to Mary and Jesus at the centre of the painting.

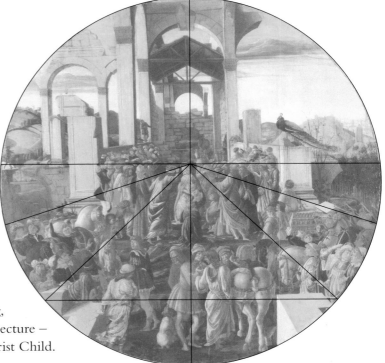

Lost in a crowd

How do you organise a round painting with more than 50 people and a dozen or so animals, without losing Mary and Jesus in the crowd? Botticelli places them right in the middle, but that meant they had to be painted quite small. Compare their size with the men in the foreground and the horse's big backside.

Botticelli used his knowledge of the rules of perspective to plan the painting, scoring lines into the gesso to mark out the architecture. The lines of the architecture – stone blocks, arches, and roof supports – lead the eye towards Mary and the Christ Child. Mary forms the topmost point of a triangle.

A new look

A picture can be carefully composed yet still give the impression of capturing a brief moment in time and space. In Degas's picture Miss La La, the trapeze artist, hangs by her teeth, spinning high in the dome of the Cirque Fernando. It is as if she is caught in a snapshot by the new magic of the camera, her body not even in the middle of the picture.

But this painting is far more than a photograph. The dramatic lighting from below illuminates the woman's figure high above our heads. The struts of the circus dome disappear into the roof space, adding to the feeling of dizzying height. We are forced to crane our necks up at her, together with the audience, and so share in the excitement of the sensational performance.

No-one had ever painted anyone quite like this before, but there was nothing haphazard about Degas's method. He made sketches at the circus, and then returned to his studio to work on the colour, the pattern and the arrangement.

Carved in stone

Mantegna's painting was made like a frieze to run along the top of a wall. You can see from the angle of the steps on the right that we are supposed to be looking up at it.

The artist set himself two problems: firstly to arrange his figures across the long, thin shape, and secondly, to make this painting look as if it was carved out of stone. He was imitating cameo, an expensive and very skilled technique in which coloured marble or stone is carved to reveal different-coloured layers.

Miss La La at the Cirque Fernando by Edgar Degas (left)
The introduction of the cult of Cybele at Rome by Andrea Mantegna (below)

Building blocks

Cézanne has imagined the scene shown in this large picture, of a group of naked woman bathing.

Artists had often painted nude figures, but these are not perfect, beautiful female bodies. They look more like heavy, solid objects in the landscape.

Cézanne composed the painting so that lines and colours connect the bathers with the sky above and the earth beneath. Their bodies reflect the blue of the sky and the golden brown of the earth.

Bathers by Paul Cézanne

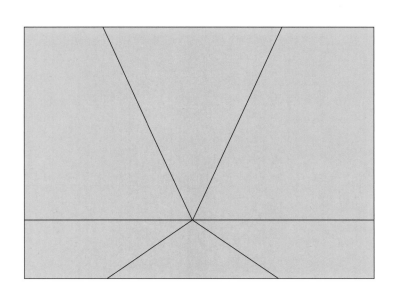

Some paintings are organised with a strong framework of lines like a skeleton under the skin. These frameworks match paintings shown elsewhere in this book. Can you identify them?

List of Artists

All the artists whose paintings are reproduced in this book are listed here. The picture titles can also be found in the index. Paintings with very long titles are sometimes given shorter titles for convenience. This list gives the short title first, followed by the full title in brackets.

Sometimes the name of an artist is not known, and he is called after his most important painting, for example, 'Master of the Saint Bartholomew Altarpiece'. We may not even know that much, and just say that a painting is by a 'French or English artist' or 'unknown artist'.

Some paintings are described in this book as 'probably by' an artist. In this list you will also find other descriptions such as 'attributed to' an artist, or by 'a follower' or 'the circle' or 'the studio' of the artist. All of these mean that we are not certain whether the picture was painted by the artist himself or by others working with him, or influenced by him.

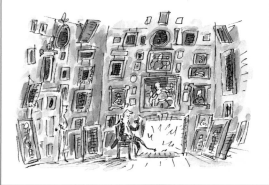

Acknowledgements

Page 22: Quotation from *Not my best side* by U.A.
Fanthorpe, from *Side Effects* (Peterloo Poets, 1978),
reproduced with permission

Page 28: Road sign, reproduced by kind permission
of Dr Albertine Gaur

Page 36: Renoir with parasol *c*.1917. All rights
reserved – Document Archives Durand-Ruel

Page 65: Picasso, *Fruit dish, bottle and violin*
© Succession Picasso/DACS 2009

Page 73: Matisse, *Portrait of Greta Moll*
© Succession H. Matisse/DACS 2009

Special thanks to Susan Bowers, Daisy Hooper,
Andrew Ross, Maro McNab and Jennifer Sliwka
for help with the preparation of this book.

Index

Titles of paintings are indexed under subjects, for example 'landscapes' or 'saints'.